CHROMA

Derek Jarman – painter, theatre designer and film-
maker – held his first one man show at the Lisson
Gallery in 1969. He designed sets and costumes for the
theatre (*Jazz Calendar* with Frederick Ashton and *Don
Giovanni* at the Coliseum). He was production designer
for Ken Russell's films *The Devils* and *Savage Messiah*,
during which time he worked on his own films in Super-
8 before making his features: *Sebastiane* (1975), *Jubilee*
(1977) and *The Tempest* (1979). From 1980 he
returned to painting (a show at the ICA) and design
(*The Rake's Progress* with Ken Russell in Florence), and
made the films *Caravaggio* (1986), *The Last of England*
(1987), *War Requiem* (1988), The Garden (1990),
Edward II (1991), *Wittgenstein* (1992) and *Blue*
(1993). His books include: *Dancing Ledge* (1984), *The
Last of England* (1987), *Modern Nature* (1991), *At
Your Own Risk* (1992) – a distillation of his philosophy
of life – and *Smiling in Slow Motion* (2000). Derek
Jarman died in February 1994.

BY DEREK JARMAN

Dancing Ledge
The Last Of England
Modern Nature
At Your Own Risk
Chroma
Smiling in Slow Motion

Derek Jarman

CHROMA

A Book of Colour – June '93

VINTAGE

Handwritten at top:

20th May, 2008
5405000295287

Published by Vintage 2000

10 9

Copyright © Derek Jarman 1994

The right of Derek Jarman to be identified as the author of
this work has been asserted by him in accordance with the
Copyright, Designs and Patents Act, 1988

The chapter 'Into the Blue' is taken from *Blue*, a film by
Derek Jarman. Copyright © Basilisk Communications Ltd 1993.
This material appears by kind permission of the producers
of the film.

First published in Great Britain by
Century 1994

Vintage
Random House, 20 Vauxhall Bridge Road, London SW1V 2SA

Random House Australia (Pty) Limited
20 Alfred Street, Milsons Point, Sydney,
New South Wales 2061, Australia

Random House New Zealand Limited
18 Poland Road, Glenfield, Auckland 10,
New Zealand

Random House South Africa (Pty) Limited
Isle of Houghton, Corner of Boundary Road & Carse O'Gowrie,
Houghton 2198, South Africa

The Random House Group Limited Reg. No. 954009
www.randomhouse.co.uk

A CIP catalogue record for this book
is available from the British Library

ISBN 9780099474913

Printed and bound in Great Britain by
Antony Rowe Ltd, Chippenham, Wiltshire

Chroma

A Book of Colour – June '93

Brilliant, gorgeous, painted, gay,
Vivid, flaunting, tearaway,
Glowing, flaring, lurid, loud,
Screaming, shrieking, marching, proud,
Mellow, matching, deep and sombre,
Pastel, sober, dead and dull,
Constant, colourful, chromatic,
Party-coloured and prismatic,
Kaleidoscopic, variegated,
Tattooed, dyed, illuminated,
Daub and scumble, dip and dye,
High-keyed colour, colour lie.

Harlequin

My book is dedicated to Harlequin, Tatterdemalion. Rag, Tag and Bobtail, in his red, blue and green patches. Mercurial trickster, black-masked. Chameleon who takes on every colour. Aerial acrobat, jumping, dancing, turning somersaults. Child of chaos.

Many hued and wily
Changing his skin
Laughing to his fingertips
Prince of thieves and cheats
Breath of fresh air.

Doctor: And how did you manage to reach the moon?
Harlequin: Well . . . it was like this . . .

(Louis Duchartre, *The Italian Comedy*)

Introduction

Curled up in the crock of gold at the end of a rainbow, I dream of colour. The painter Yves Klein's International Blue. Blues and distant song. The eye, I know, described by the fifteenth-century architect Alberti, 'is more swift than anything'. Fast colour. Fugitive colour. He wrote those words in his book *On Painting*, and finished it at 8:45 on Friday 26 August 1435. Then he took a long weekend . . .

(Leon Battista Alberti, *On Painting*)

When Mark, my editor, came down to Prospect Cottage we talked of colour. Of blues and reds, and how the research last year for the Blue Concert, which Simon Turner is performing in front of the Golden Temple in Kyoto at this very moment, threw me deep into the spectrum. Mark has gone now. I sit here in the silence of my new room, from which I can see the power station at Dungeness in the twilight:

Look at your room late in the evening when you can hardly distinguish between colours any longer – turn on the light and paint what you saw in the twilight. There are pictures of landscapes or rooms in semi-darkness, but how do you compare the colours in such pictures with those you saw in semi-darkness? A colour shines in its surroundings. Just as eyes only smile in a face.

(Ludwig Wittgenstein, *Remarks on Colour*)

In the morning I looked through the indexes of my books – who had written on colour? There was colour in . . . philosophy . . . psychiatry . . . medicine . . . as well as art, and observations echoed across the centuries:

At this juncture we ought to say something about lights

1

and colours. It is evident that colours vary according to light, as every colour appears different when in shade, and placed under rays of light. Shade makes a colour dimmer, and light makes it bright and clear. Colour is swallowed by the dark.

(Alberti, op. cit.)

At night I dream of colour.
Some dreams I dream in colour.
My colour dreams I REMEMBER.

This one from thirty years ago . . .

I dream of a 'Glastonbury Festival'. There are thousands of people camping around a pure white classical house isolated on a perfect green sward. Above the front door, the frieze on the tympanum is painted in pure pastel colours depicting the good deeds of the owner. Whose house is this? The answer is given to me by one of the revellers – 'The house of Salvador Dali.'

Since then I've looked at Dali's paintings and found little colour in them.

As a child I became aware of colour and its changes, distempering the walls of a mildewed RAF Nissen hut. My father placed a bright yellow rubber dinghy on the lawn, used a hosepipe to fill it, and after we finished work we swam in the golden water. Ever after, I thought of water as yellow and struggled as a teenager painting reflections – and then 'the Moderns' marched in before I had time to get to the Academy.

I reject the soul and intuition as unnecessary – on February 19th 1914 at a public lecture I rejected reason.

Or this sound advice . . .

2

Only dull and impotent artists screen their work with sincerity. In art there is need for truth, not sincerity.

(Kasimir Malevich, *Essays on Art*)

May my black Waterman ink spill out the truth.

Chemistry and romantic names – manganese violet, caerulean, ultramarine, and distant places, Naples yellow. The geography of colour, Antwerp blue, raw Sienna. Colour stretching to the distant planets – Mars violet; named after old masters – Van Dyke brown. Contradictory – Lampblack.

'Eyes are surer witnesses than ears,' says Heraclitus. Though there is no colour in the fragments that remain to us of his work.

(trans. Khan, *Heraclitus*)

At school if I wasn't playing at Impressionists or Post-Impressionists (copying Van Gogh blossom and ingratiating myself with Miss Smith, the matron, by giving her my faltering copy) I was trying to make the colours frighten each other . . . In the background black and white images flickered on the TV. I escaped from this into the cinema, where colour was better than the real thing.

People in art are not people,
Dogs in art are dogs,
Grass in art is not grass,
A sky in art is a sky,
Things in art are not things,
Words in art are words,
Letters in art are letters,
Writing in art is writing,
Messages in art are not messages,
Explanation in art is not explanation.

(Ad Reinhardt, *California*)

3

All colour smells of turpentine and rich linseed oil pressed from the pale blue flax fields. Local colour from coloured fields. The cricket bat dipped with the brush. Death hangs around the brush – pigs' bristle, squirrel, sable, and the canvas prepared with rabbit skin glue.

I learnt colour but did not understand it.

I collected the little pans of watercolour, sticky in their silver wrappings, but never opened them. Scarlet lake. Ivory black. Windsor blue. New gamboge. I worked in grown-up oils.

Trips up to London in the holidays to Brodie and Middleton, Colourmen of Covent Garden, makers of cheap oil paint in tins. 'Brunswick green' my cheap favourite. Vermilion, *très cher mes amis, très cher* these reds. Yes, the reds cost us. The colours in my paintings were dictated by cost. I mixed on a glass palette, colours that went beyond Windsor and Isaac Newton – nameless colours . . .

Others we named ourselves . . .

GOOSE TURD GREEN or VOMIT.

What is pure colour?

> If I say a piece of paper is pure white, and it's now placed next to snow, and it then appeared grey. I would still be calling it white and not light grey.
>
> (Wittgenstein, op. cit.)

Where in red is the true red? The original prime colour to which *all* other reds aspire?

Teenage musings stuck with tubes of students' Georgian colour. (Artists' colour beyond our pockets.) I left university

and hitch-hiked to Greece. White islands, blue washed walls, white marble *phalloi* at Delos, blue cornflowers, the scent of thyme.

I returned to London on the back of a lorry where I started as a painting student at the Slade, as the leaves turned brown on the plane trees and a slight blue mist fuzzed the soot-black churches.

In the Sixties, boys started to wash between their legs. Do you remember those adverts for B.O.?

And along with the boys, London scrubbed off its sooty nineteenth-century patina. Meanwhile, the paintings were being scrubbed of the patina of centuries by Mr Lucas of the National Gallery. Some said he was actually repainting them completely. When he wasn't knocking up a Sodoma he taught us how to grind colours and prime canvas.

A trip to Cornelissen in Great Queen Street, a shop that had been there for 200 years, with jars of pigment glinting like jewels in the semi-dark, where I bought the colours to make my own paint. Manganese blue and violet. Ultramarine blue and violet and the brightest permanent green. These colours carried health warnings – a black and scarlet skull and cross-bones, and the words DANGER – DO NOT INHALE.

My first day at the Slade . . . lost in the early morning corridors, alone and nervously waiting for the life class in the huge drawing studio, when suddenly a jolly middle-aged lady with gaudily hennaed hair appeared in a floral kimono from behind a screen. I hadn't noticed her when I'd come in. I stared wide-eyed as she threw off the flowers and stood stark naked in front of me – not at all like the demure Botticelli Venus that I expected, more like the Duchess of York.
 'How do you want me, darling?'
 Noting my embarrassed silence, she said, 'Oh, artistic!' and took up a pose, instructing me to draw round her with

blue chalk. Red in the face, with a shaking hand, I did as she commanded. You see, I was very green. The Slade professor, Sir William Coldstream, appeared high on the balcony that led from his office to the life studio to observe what was going on. I sat on my donkey, trying to cover my first and inexpert charcoal marks from his gaze. Life as a painter had begun.

Grey was the colour of the Slade. Sir William wore grey suits. My tutor, Maurice Field, who had iron-grey hair, wore an iron-grey laboratory coat. Squinting at me through his gold-rimmed spectacles he said, 'I know nothing about modern colour – but we could talk of Bonnard.' So we talked of Bonnard. And he said hardly a word about my work. Maurice had taught Sir William to paint slowly, and Sir William had taught all the other tutors to paint even slower. But we were a generation in a hurry. After all, The Bomb was expected to drop at any moment. So the Slade style, after the model, with little flat, grey areas and pink crosses to show you had measured her up with a pencil held at arm's length, painting the paraphernalia of painting, held little interest for me. At school I'd left the Post-Impressionists behind, had dabbled like a child in a sweetshop in Cubism, Suprematism, Surrealism, Dada (which, I noted, wasn't an ' . . . ism') and finally in Tachism and Action painting.

After I'd got through the modern movement in my neighbour Güta's attic, I took to conventional British landscapes – the first work I recognised as my own. The gift of summer days spent drawing in the Quantocks, in the little lanes that led down to the Bristol Channel at Kilve. Red earth and dark green hedges. My maiden aunts admired the results. I grew more adventurous, and painted a series of interiors entirely in pink, abandoned them and took to shrill colouring again. Arsenic greens fought out the pinks until they in turn were swallowed and defeated by monochrome.

6

What is pink? A rose is pink
By the fountain's brink.
What is red? A poppy's red
In its barley bed.
What is blue? The sky is blue
Where the clouds float through.
What is white? A swan is white
Sailing in the light.
What is yellow? Pears are yellow
Rich and ripe and mellow.
What is green? The grass is green,
With small flowers between.
What is violet? Clouds are violet
In the summer twilight.
What is orange? Why, an orange,
Just an orange!

(Christina Georgina Rossetti, 'What Is Pink?' From
Sing-Song)

White Lies

The first of all simple colours is white, although some would not admit that black or white are colours, the first being a source or receiver of colours, and the latter totally deprived of them. But we can't leave them out, since painting is but an effect of light and shade, that is chiaroscuro, so white is the first then yellow, green, blue and red and finally black. White may be said to represent light without which no colour can be seen.

(Leonardo da Vinci, *Advice to Artists*)

Potters Bar fête 1906. I still have a cherished postcard from which I painted several pictures as a teenager. Edwardian girls in long white dresses, lampshade hats and frilly parasols blown like thistledown out of the nineteenth century. Who were they? Looking so solemn under the fluttering bunting. Facing the swings and roundabouts of life. I don't know what I found so alluring about these girls in white dresses in the parks, piers and promenades, paddling in the sea with their skirts hitched up in paintings by Wilson Steer. Turn of the century white, inspired perhaps by Whistler's monochromatic portrait *The White Girl*. Throw a paint pot in the public's face and they will catch it. Here they are again, sitting in the garden on white garden benches, sipping tea from white porcelain, the gift of China, looking at a postcard from an elder brother who is climbing Mont Blanc. Dreaming of white weddings . . .

Ghostly white postcards. As I look at them now, the girls are blissfully unaware of the wall of death which will change their Sunday best but not its colour, a few short years ahead. They will become nurses, factory girls, maybe engineers or

even aviators. Behind the postcard there is white. Behind the painting there is white ground.

White stretches back. Was white created in the Big Bang? Was the bang itself white?

In the beginning was white. And God made it, of all the colours, and this was a secret until Sir Isaac Newton sat in a darkened room late in the seventeenth century:

THE PROOF BY EXPERIMENTS

Whiteness and all grey Colours between white and black, maybe compounded of all Colours, and the whiteness of the Sun's Light is compounded of all the primary Colours mix'd in a due Proportion. The Sun shining in a dark Chamber through a little round hole in the Window-shut and his Light being there refracted by a Prism to cast his coloured Image upon the opposite Wall: I held a white Paper to that image in such a manner that it might be illuminated by the colour'd Light reflected from thence . . .

(Sir Isaac Newton, *Opticks*)

Looking back through Sir Isaac's prism, is it possible to see Osiris, the God of the White Nile, God of Resurrection and rebirth, in his white crown and white sandals, devoid of colour? Then white was without colour, something which after Newton we can no longer experience. Perhaps the green sceptre that the God holds to herald the return of spring, like the snowdrop, tells us this.

White is the dead mid-winter, pure and chaste, the snowdrop, *Galanthus nivalis* (Candlemas bells), decorated the churches on February the second, the Feast of the Purification of the Virgin . . . but don't bring those snowdrops into your house – they'll bring you bad luck, you might even drop dead: for the snowdrop is the flower of the dead, resembling

a corpse in its shroud. White is the colour of mourning except in the Christian West where it is black – but the object of mourning is white. Whoever heard of a corpse in a black shroud?

If you spin a colour wheel fast enough it turns white, but if you mix the pigments, however much you try, you will only get a dirty grey.

> That all the colours mixed together produce white, is an absurdity which people have credulously been accustomed to repeat for a century, in opposition to the evidence of their senses.
>
> (Johann von Goethe, *Theory of Colour*)

Light in our darkness.

As the wheel spins a mandala is created. In it you see that the Gods are white; centuries before Saint John invented the Christian Heaven, with the Heavenly Host in white worshipping the Lamb, the Greeks and Romans were celebrating Saturnalia – 17 December. The melancholy Saturn, like Osiris and the coming Christ, was a white god, worshipped in white with a touch of Osiris green in the palm leaves his worshippers held in their hands. The Feast ended on New Year's Day when the Consul, arrayed in white and riding a white horse, celebrated the triumph of Jupiter on the Capitol.

I'm dreaming of a white Christmas. This song could only be sung in southern California around a swimming pool. Here, at the first hint of snow British Rail runs to a standstill, the roads become impassable, and even the pavements are a danger as the salt destroys your shoes. Christmas, born of a virgin. White cotton. Wool beards. And a gross exchange of superfluous gifts. The barometer of the mind drops into

11

depression. A child of good intention who brought the opposite: fear, loathing, mad American preachers who shout at you. A saviour who saved nothing but the illusions of his own, and certainly not the white Christmas turkeys boiled alive after standing in a crowd for a year (yes, they're dreaming of a white Christmas!).

The entire kingdom was ordered into mourning for Mumtaz Mahal for two years and a silent gloom spread over Northern India. There was no public entertainment, and no music, no jewellery, perfumes and other fineries, brightly coloured clothes were forbidden, and anyone who dared disrespect the memory of the Queen was executed. Shah Jehan kept away from the public eye, the same emperor who once wore a robe so heavily encrusted with gems that he needed the support of two slaves, now dressed in simple white clothes.

(Shalin Savan, *Shah Jehan, The Taj Mahal*)

White has great covering power. The whitewashed family does not question the bride's blushes beneath the veil.

Desire flaunts itself in the face of pure white, but is buried by the wedding dress. The bride has hidden her scarlet and black fuck-wear, bought in Soho, for the honeymoon. White lace camouflages her pregnancy. The groom's best friend, David, is whispering in his ear, 'Cum in my mouth! Cum in my mouth!'

One book opens another. The tears of Saturn form the wide salt sea. Salt is bitter and sad. Salt mines. The salt of the earth is its soul, so precious, if you drop it throw a pinch of it over your shoulder. The wisdom of an old salt. After the salt was blessed it was sprinkled in the baptismal waters. Christ is the salt which makes our earthly bodies incorruptible. Salt is the divine wisdom. So valuable is it, that it is placed in

jewelled reliquaries at the High Table. St Hilary said, 'Let the world be sprinkled with salt, not deluged with it.'

Isn't white that which does away with darkness?

(Wittgenstein, op. cit.)

In my grandmother's living room, my mother and I play Mah-Jong. Building walls with little ivory bricks. On the mantelpiece are two ivory miniatures of the Taj Mahal, its marble funereal white. All the ancient monuments are ghostly white, the statues of Greece and Rome were washed of their colours by time. So, when the Italian artists revived antiquity, they sculpted in white marble unaware that their exemplars were once polychrome – who sculpted the whitest? Canova? A deathly Cupid and Psyche? The Three Ghostly Graces? Ghosts from the antique. The world had become a ghost for artists.

1919. The world is mourning. Kasimir Malevich paints *White On White*. A funeral rite for painting:

I have transformed myself IN THE ZERO OF FORM and dragged myself out of the rubbish-filled pool of academic art. I have torn through the blue lampshade of colour limitations, and come out into the white. I have conquered the lining of the Heavenly, have torn it down and, making a bag, put in colours and tied it with a knot. Sail forth! The white, free chasm, infinity is before us.

(Malevich, op. cit.)

The chemistry of the paint with which Kasimir painted his famous picture was as old as pigment. I doubt that he used titanium, which was only just discovered; perhaps he used zinc oxide, a mere one hundred years old. It's most likely he

13

used lead oxide which stretched back to the antiquity he despised. All the whites with the exception of the chalk-based grounds like gesso are metal oxides. White is metallic.

Flake white. Thin sheets of lead oxidised in the dung-heap produced the heavy white impasto on which Rembrandt balanced the heads of his sitters, leaden ruffs, heavy with starch and propriety.

> A colour made alchemically from lead is white. It is called white lead. This white lead is very brilliant, and it comes in little cakes like goblets or drinking glasses. The more you grind this colour the more perfect it will be and it is good on panels – it is even used on walls but avoid it as much as you can for in the course of time it turns black.

(Cennino Cennini, *Il Libro dell'Arte*, translated D V Thompson)

When will Kasimir's *White On White* turn to *Black On Black*?

Pliny writes a recipe:
Lead decomposes in jars of vinegar to produce the ground on which we paint.

White lead is very poisonous, and if used unwisely leads to painters' sickness.
Rome poisoned itself with leaden wine vessels. Is the madness of painters like that of hatters? In the chemistry of their art?
Olympiodorus warns us that lead is so possessed by devils and is so shameless, that those who want to learn about it fall into madness and death.

Zinc oxide, Chinese white, originates as a cold white smoke, it is not poisonous and has been used as a pigment since the mid-nineteenth century. Zinc vapour from the molten metal

14

is burned in an oxidising atmosphere at a temperature of 950° centigrade, producing fumes of white oxide. Zinc oxide is a pure cold white.

The whitest of whites is titanium which has the greatest hiding power of any of the whites. It is very stable, unaffected by heat, light or air and is the youngest of the whites, having been introduced after the First World War.

The current price for these pigments from Cornelissen, the artists' colourmen, is:

Flake white	£15.85
Titanium white	£22.50
Zinc white	£26.05
FOR FIVE KILOS	

White shuts out, is opaque, you cannot see through it. Power-crazed white.

In 1942, I was born in Albion, a little white, middle-class boy, behind the great white cliffs of Dover, which defended us against the black-hearted enemy. As I was christened, the white knights fought an aerial battle through the cumulonimbus clouds above Kent. At four, my mother took me to see the sights – the great White Tower of London, no longer limewashed, but grey and sooty. Whitehall, where the Houses of Parliament were even blacker. I learnt quickly that power was white, even our American cousins had their own White House, built like the imperial monuments of antiquity in marble. Marble was expensive, and the living, out of respect for the dead, recorded their passing in marble monuments. One of the most lavish of these is the monument in Rome to Vittorio Emmanuele and the Risorgimento – a building in the worst of taste known by the Romans as the 'Wedding Cake'. On my fifth birthday I stood in front of this White Elephant awestruck. After a brief sojourn in Italy we returned home. I was six, my education began in earnest

at Hordle House on a Hampshire cliff top in sight of the Needles. Behind a Fifties education lay the great White Imperial Burden. Privileged, we of the White Hope were to care, maybe even sacrifice ourselves, for the countries coloured pink in our school atlas.

At seven, I embarrassed my military father asking for a white arum lily as a birthday present, rather than the dead lead soldiers he would have preferred. My childish passion for flowers he thought sissie; he hoped I would grow out of it. I've never had an obsession with white flowers like Vita had at Sissinghurst, though I do have a favourite, the old clove-scented pink, with its shaggy petals, Mrs Sinkins. Gertrude Jekyll, the great Edwardian gardener, loved this flower, though she would have taken me to task for describing it as white:

> Snow white is very vague. There is always so much blue about the colour of snow, from its crystalline surface and partial transparency, and the texture is so unlike that of any kind of flower that the comparison is scarcely permissible. I take it that the use of snow white is like that of golden yellow, more symbolical than descriptive meaning of any white that gives the impression of purity.

> Nearly all white flowers are yellowish white and the comparatively few that are bluish white such examples as *Omphalodes linifolia* are of a texture so different from snow that one cannot compare them at all – I should say that most white flowers are near the colour of chalk; for although the words chalky white have been used in a rather contemptuous way, the colour is really a beautiful warm white, but by no means an intense white.

> The flower that always looks to me the whitest is that of *Iberis sempervivens*, the white is dead and hard – like a

16

piece of glazed stoneware quite without play or vari-
ation, and hence uninteresting.

(Gertrude Jekyll, *Wood and Garden*)

At nine, my Christmas present was the two volumes of
Trevelyan's *Illustrated English Social History*. I don't think I
read it! But I'd fallen in love with the pictures – particularly
the miniature by Nicholas Hilliard of a young man, who
leans lovesick against a tree, his hand on his heart, entwined
with white roses. He wears a white ruff, a slashed white and
black doublet, white hose and white shoes. Perhaps he lived
in one of the black and white timber houses which were also
illustrated in the book, and from which I made countless
drawings, more fantastical even than None-Such Palace. A
world of white turrets, spires and towers . . . above which an
aerial battle was fought. I think these drawings reflected my
inner turmoil, the battle that had raged throughout my child-
hood, the bombers and air raid sirens, while down below
was a threatened home. Home in black and white.

The advance of white in the twentieth century was delayed
by the Second World War. The architect Corbusier's Les
Terrasses painted in a cream white – and his Villa Savoie
(1930), a pure white, had inspired a thousand imitations
which sprang up along the seaside. This pure and domestic
modernity had fallen victim to the Final Solution – Hitler's
architect Albert Speer's dream of a neo-classical revival was
achieved much later in Mrs Thatcher's post-modern 1980s.

In the ruins of the war, colour was reinstated. The pastels of
the 1950s, each wall a different shade, pale shades of Mon-
drian's bright and scintillating *Broadway Boogie Woogie*.

1960. In the white heat of Harold Wilson's Technological
Revolution we reinstated white. Out came the white lino
paint, and white emulsion covered the browns and greens of
our Victorian past and those Fifties pastels. Our rooms were

17

empty, pure and dazzling, though difficult to keep that way as feet soon scuffed the white off the floorboards. In the middle of the room the black Braun fan heater whirred unsteadily – grandfather of the devilish black technology of the Eighties. The black at the centre of the white. At the cinema *The Knack*, with Rita Tushingham painting her room a pure white, art following our lives.

In this white we lived coloured lives. It was a brief moment. By 1967 the jumbled psychedelic rainbow flooded the room.

On the television a battle for purity raged: Persil washes whiter than white, blue-white, Daz, Fairy Snow, Tide, the battle of Dad's white shirt – what a debt we owe to ICI and the chemical factories. Priestly whitewashed whiter, cricket whites, tropical suits, reflecting the sun back at itself. The painter high on his scaffold with his white overalls splashed with white paint, the Carmelite monk and nursing sister. All that dull refinement, bleached white sugar, bleached the sacred grain. I once met an excited Frenchman in a supermarket; he had packed a dozen loaves of white sliced bread for his friends in Paris.

Queer white. Jeans hugging tight arses. Sarah shouts from the garden: 'Oh, *that's* how the gay boys recognise each other in the night!' White Nights in Heaven, a gay bar, which would have thrilled Saint John, dazzling T-shirts and boxer shorts achieved after days spent poring over the washing machine's finer programme.

All this white inherited from sport – sportif. The white that contrasted with the green of the pitch. Note that green and white are together again. This white needs self-control . . . you cannot spill a drink or mark the virgin cloth. Now only the foolish or very rich wear white, to wear white you cannot mix with the crowd. white is a lonely colour. It repels the unwashed, has a touch of paranoia, what are we shutting out? It takes hard work whitewashing.

Passing through the Great Salt Lakes of Utah on the Greyhound bus. Shimmering white salt stretched to each horizon, blinding the eyes.

> I am summoned from my bed
> To the Great City of the dead
> Where I have no house or home,
> But in dreams may sometime roam
> Looking for my ancient room.
>
> (Allen Ginsberg, 'White Shroud')

In the first white light of dawn I turn white as a sheet, as I swallow the white pills to keep me alive . . . attacking the virus which is destroying my white blood cells.

The wind has blown without end for five days now, a cold north wind in June. The sea, whipped into a thousand white horses, attacks the shore. Plumes of salt blow in veils coating the windows with brine and burning the flowers. Leaves are blackened and the red poppies too, the roses are wilting, here today and gone tomorrow; but the white perennial pea is untouched. In the distance the white cliffs appear briefly before they are swallowed in the haze. I am shut in, to walk in the garden hurts my tired lungs.

The white seahorses have brought a madness here, irritable, straining at the bit. I hate white.

Then standing in the garden I notice a white flower among the blue viper's bugloss. On closer inspection it turns out to be a single albino sport. No one has ever seen one before. Is it an omen? I mark it to collect the seed, and name it after my friend Howard who has taken the photograph on this book's jacket – *Arvensis sooleyi*.

Lichtenberg says that very few people have ever seen pure white, so do most people use the word wrong,

then? And how did *he* learn the correct use? He constructed an ideal use from an ordinary one and that is not to say a better one, but one that had been refined along 'certain' lines and in the process something has been carried to extremes.

<div align="right">(Wittgenstein, op. cit.)</div>

Van Gogh, pale melancholic, haunted in the garret of his mind, his ashen face tinged with green shadows. Child of Saturn. White from long nights in the mind's laboratory. Can you put a face to him?

A snowstorm in a glass globe dropped by a child. The red water in the globe splashes over the white sheets on his bed. 'I told you not to play with that!' The sheets, the bloody sheets. A scarlet accident in a snowstorm. Red-faced and angry. The child's sobbing and the red that never washed out, so the sheets remained a witness to the accident.

The blood of a wounded animal shot by hunters stains the clean snow. There is always a tremor when you see pools of blood splattering a street. A fight? A knifing? Maybe a murder?

The snow is blinding, blowing in the face of the winter queen at the battle of the White Mountain. What memories she must have had, moving her one set of furniture from room to room in her ruined palace in the Hague. Elizabeth of Bohemia for whom *The Tempest* was first performed at her marriage ceremony back in 1612.

Storms beat on the stone walls, snow, the herald of winter, falling thick binds the earth when darkness comes and the night shadow falls, sending bitter hailstones from the North in hatred of men.

<div align="right">(The Wanderer, c900)</div>

White and battle – Teutonic Knights sliding to their deaths from icebergs.

We travelled north on an icy February morning on the train from Euston, through a landscape touched by Jack Frost. Woods, fields and hedgerows. A blinding crystalline white etched against a blue sky. The hoar frost shimmered whiter than snow, each leaf and twig, the frozen grass. Motionless white. The hills and valleys hallucinated. I only saw this once, except on postcards. The beams of the February sun, brighter than midsummer, melted the crystals, and by the time we reached Manchester it was a memory. There is no way we could describe what we saw, it would be as impossible as describing the face of God.

White out in the north, the snow-blind polar bears howling.

Shadow Is the Queen
of Colour

I am in search of Miracoli and Memorabilia, like old Pliny in his *Natural History*. The further colour recedes in time and space the stronger it glows. Golden memories. Not the gold of wedding rings in the High Street Ratners, but a philosophic gold which glows in the mind like the precious stones in *Revelation*. Emerald, Ruby, Jacinth, Chalcedony, Jasper. Colour, like these jewels, is precious. Even more precious, as unlike the sparklers, it cannot be possessed. Colour slips through the fingers and escapes. You can't lock it in a jewel box as it vanishes in the dark.

In his *Natural History*, Pliny was certain that Luxuria was the enemy. There was a time before, before men wore gold rings, before they raised statues to themselves in precious metals. A time when Mother Nature was not pillaged and plundered, for yellow, and blue, and vermilion, though nature could hold her own against man, poisoning him not only with plants and animals, but also with colours. Pliny says that painters wore bladder masks to protect themselves from the dust of vermilion as they painted the statue of Jupiter. We must explore this subject more closely, he says.

Turn the clock back 400 years.

Aristotle's book *On Colour* is the first. In the year that boy-kissed Alexander died, 323 BC, Aristotle was teaching in Athens. The next year he was dead in his villa at Chalcis, where he escaped from political turmoil, leaving his school in the charge of Theophrastus.

Aristotle opens his book this way:

Those colours are simple which belong to the elements,
fire, air, water and earth. For air and water are
naturally white in themselves, while fire and the sun are
golden. The earth is also naturally white, but seems
coloured because it is dyed. This becomes clear when
we consider ashes, for they become white when the
moisture which caused their dyeing is burnt out of
them.

Aristotle's theories were to trap the western mind for 2000
years, until the Renaissance started to unlock doors. Aristo-
telian wisdom was quoted, requoted and quoted again. No
one burnt the Earth to see if it was white, or untangled the
colours from the elements. For Aristotle was enlightened
. . . 'And darkness follows when light fails.' Not until
Leonardo was this reversed, and light followed as darkness
failed.

Aristotelian black had its own logic. He grapples with this in
his second paragraph. Black conveys no light to the eyes. All
things appear black when a small amount of light is re-
flected. The failing light produces shadows. From this one
learns that darkness is not a colour at all, merely an absence
of light. It is not possible to see the shapes of things in the
dark.

Aristotle conceives the colours from a mixture of black and
light:

When what is black is mixed with the light of the sun
and fire, the result is always red.

From observations like this he conceived a theory of colour
in which black was always present, in greater or lesser
quantity.

He noticed that the air had a purple tint at the rising or the
setting of the sun:

24

The colour of dark wine occurs when sunlight rays are mixed with what is pure black, like the berries of the grape . . . for their colour is said to be wine-dark at the moment of ripening, for when they are growing black, red changes to purple. According to the method we have laid down we must inquire into all the variations of colour.

He says we should make our investigation, not by mixing colours as painters do, but by comparing the rays that are reflected.

A storm is rolling down the mountains. The younger Pliny, strolling in his box-scented garden, is interrupted by the first fat drops of rain as he discusses planting an orchard with his old gardener. He hurries back across the marble courtyard, dodging the water of the fountain which blows across the mosaics, through the folding doors into his bedroom. There on his couch he picks up Aristotle's *On Colour* in the dappled green light of the enormous vine that climbs to the top of the roof. In this room, he says, you can 'imagine you are in a wood without the risk of rain'. As the storm grows in intensity, Pliny would agree with Aristotle that the darkness enveloping his room was not a colour but an absence of light. And if he felt a sudden chill and called his slave to light the fire, he would see with Aristotle that the wood turned black when burning, then red. If Pliny walked to his window and picked a bunch of wine-dark grapes, he would know that the colour of wine-dark red is mixed with what is pure black. To find proof for his theory of the mixing rays in nature, Aristotle says, we require convincing proof and a consideration of similarities if the origin of colours is to become obvious:

All colours are a mixture of three things, the light, the medium through which the light is seen such as water and air, and the colours forming the ground from which the light happens to be reflected.

Some colours are sombre and some are brilliant. The brilliant colours are cinnabar, vermilion, armenium (a deep blue), malachite (a vivid green), indigo, and a bright Tyrian purple. The sombre colours are synopses (a red-brown), paraetonium (a chalk-white), and orpiment (a bright yellow). Black is produced by burning resin or pitch.

On Colour is solely concerned with Nature. There is no mention of the art of painting, and little interest in the source of dyes ... though Aristotle mentions the *Murex* which gave the Imperial purple. He observes flowers, fruits, the roots of plants and the changing colours of the seasons. The green leaves turning yellow. Plants are penetrated by moisture which washes the colours into them. This is fixed by sunlight and warmth, just as occurs in dyeing. All growing things become yellow at the end:

> As the black grows steadily weaker, the colour changes gradually to green and at last becomes yellow . . . other plants become red as they ripen.

Aristotle uses the green vegetable leek, blanched by the lack of sun to white to confirm his theory that sunlight creates colour. His book *On Colour* is short, and Pliny finishes it before the storm passes with a flash of lightning, a clap of thunder and a sudden silence which is broken by the laughter of his young slaves. His garden of mulberries, figs, roses and neat topiary pyramids of box shaded by cyprus is refreshed by the sudden downpour. A breeze has sprung up.

Pliny writes a letter to Baebius Macer (Baby):

> I am delighted to hear your close study of my uncle's books has made you wish to possess them all. The *Natural History* is as full of variety as Nature herself.

His uncle, he said, needed little sleep, and devoted every

26

spare minute to writing when he wasn't busy at the Bar. He was up each day before dawn to visit the Emperor Vespasian. He carried his notebooks on his journeys. He even read books in the bath. No wonder such a busy man often dozed off. Books thirty-three to thirty-five of *Natural History* are devoted to the arts of sculpture and painting. For the elder Pliny the purpose of art is to confound Nature, and his highest praise is for those who have achieved this: Zeuxis, who fooled the birds with a bunch of painted cherries; Apelles, who painted a horse which caused real horses to neigh; and Parrhasius, who painted a curtain that fooled Apelles when he asked him to draw it back to see the painting he imagined it covered. Art reaches perfection when it reflects Nature. Nature herself is the judge.

But I am straying from the mines of colour, the purpose of this book. On this, Pliny is as eloquent as any of the ancient writers. The reason for this is not just his insatiable curiosity, but because he puts himself and his prejudices so strongly into his writing. Most later books on colour fail to do this, and therefore remain colourless. Pliny says, 'In the good old days painting was an art.' Painting in Rome had degenerated to spectacle. Nero had his portrait painted half the size of a football pitch, and had hidden an art that should always be public in the gigantic prison of his Golden House. Everything was awry, and untrammelled riches were the cause. If the emperors were profligate, the magnates were worse. Augustus had clad the public memorials in marble which created an insatiable lust for this stone. Nature was raped. Mines destroyed and disfigured the living goddess, mountains were toppled and rivers diverted in the scramble for precious stones and metals. Our age is out-of-joint. Look at this: Drusilianus Rotundus, the Emperor Claudius' slave, had a plate fashioned in solid silver that weighed 500 pounds, and eight smaller plates each weighing 250 pounds. How many men are required to lift it, and who can use it? The luxury of private houses affronts the temples. Columns of costly African marble are dragged through the streets to

make a dining room – a hideous contrast with the simple ter-racotta of the old shrines. The weight of these columns has destroyed the sewage system.

Pliny tells us that the use of silver for statues of his late lamented majesty Augustus was due to the sycophancy of that period . . . but, if you could see the displays of luxury now, 'women's bathrooms with floors of silver leaving no-where to set your feet. And the women bathing in company with men!' it would leave you breathless. In the silver mines the pigments, yellow, ochre and blue, are quarried. One of the best is called Attic slime, and it costs two denarii a pound. Dark ochre from Scyros is used for shadows in paint-ing. Yellow ochre was first used for highlights by the Greeks. The blue pigment is a sand. In the old days there were three varieties: the Egyptian, most highly thought of; the Scyth-ian; and the Cyprian. To these have been added Pozzuoli blue and Spanish blue. From this is made blue wash, and it is also used to paint window frames because it does not fade in the sunlight.

Indian blue, indigo, is employed in medicine, as is yellow ochre, an astringent.

Verdigris is suitable for eye salves. It produces watering in the eyes, but it is essential to wash it off with swabs. You can buy it under the name of Hierax's Salve. Pliny then lists the medical uses of other metal oxides. Lead, for instance, is applied to the lower regions, for its chilly nature, to check attacks of venereal passion and libidinous dreams. One of the more unusual uses of lead was the plate that Nero had fixed to his chest when singing songs fortissimo to preserve his voice.

This colourful emperor, who had a passion for theatre, burnt Rome down for an evening's entertainment and had the de-lightful habit of crucifying people in his gardens, is not one of Pliny's favourites. There is more than a little irony in the

words, 'Whom Heaven was pleased to make emperor.' Other emperors were more public spirited, and commissioned paintings to decorate the city.

There are many colours now, but only four colours were used by the great Greek painters. Everything was superior when there were fewer resources. Nowadays, it is the value of the materials and not the genius of artists which people look for. What people are really interested in now are the lifelike portraits of gladiators. Everything is but a shadow of a golden past. The colours will fade in the twilight of history.

On Seeing Red

What's black and white and red all over?

> If one says red (the name of a colour) and there are fifty
> people listening it can be expected there will be fifty
> reds in their minds, and one can be sure that all these
> reds will be different.
>
> (Josef Albers, *Interaction of Colour*)

A red eye test. The eyes are most sensitive to red. My eyes
were tested in St Bartholomew's by Peter this morning. I
had to look him in the eyes while he moved a red-tipped pen
into my field of vision. At a certain point, the grey flashed to
a bright red. As bright as a traffic light.

> To begin teaching someone: 'That looks Red' makes no
> sense, for he must say that spontaneously, once he has
> learned what Red means, ie learnt the technique of
> using that word. For if someone has mastered the use of
> what looks red – or indeed what looks red to me – he
> must also be capable of answering the question, 'And
> what is Red like?' and 'What does something look like
> when it turns Red?'
>
> (Wittgenstein, op. cit.)

Red. Prime colour. Red of my childhood. Blue and green
were always there in the sky and woodland unnoticed. Red
first shouted at me from a bed of pelargoniums in the court-
yard of Villa Zuassa. I was four. This red had no boundary,
was not contained. These red flowers stretched to the
horizon.

Red protects itself. No colour is as territorial. It stakes a
claim, is on the alert against the spectrum.

31

Red adapts the eye for the dark. Infra-red.

In the old garden red had a smell, as I brushed the leaves of
the zonal pelargonium, scarlet filled my nostrils. I have
called the plant formal pelargonium rather than geranium,
as geranium conjures a dirty pink. The scarlet of Paul
Crampnel is the perfect scarlet. The scarlet of flower beds;
civic, municipal, public red, reflected in the jolly red buses
that bring a touch of joy to the dank grey streets.

Iris, the Rainbow, gave birth to Eros, the heart of the mat-
ter. Love, like the heart, is red. Not the colour of red meat,
but the pure scarlet of flowers. Could you conceive of a
bloody heart on a Valentine? All is fair in love and war, and
red is without doubt the colour of war. The colour of life
departing from a broken heart is a trickle of red blood.
Sacred heart of Jesus.

'My love is like a red red rose.'

> The French have a happy expression for the less per-
> ceptible tendency of yellow and blue towards red. They
> say the colour has an *oeil de rouge*, which we might ex-
> press by a reddish glance.
>
> (Goethe, op. cit.)

Love burns in the passion of red.
Marilyn sprawled on the scarlet sheets.
Heart-throb.
She is 'the rose of the bloody field'.
The rose of Jericho that grew in Bedlem.

Vino Santo. Vin rouge. Plonk. Shut your inebriate eyes and
see red forever after.

> Red which is the consequence of a powerful impression
> of light may last for some hours.
>
> (ibid.)

If you look the light of the world in the eyes, creation turns scarlet.

In the hospital they drop stinging belladonna in the eyes to open the pupils, and then take photos by flashlight. Is this that moment in Hiroshima? Did I live to tell the tale? For a fraction of a second there is a sky blue circle, and then the world reassembles itself in magenta.

I'm four again. Zonal pelargoniums light up my eyes. There I am picking huge bunches of them in the mind's eye of Dad's movie.

I am sitting here writing this in a bright red T-shirt from Marks and Spencer. I shut my eyes. In the dark, I can remember the red, but I cannot see it.

My red pelargoniums, the colour of flaming June, have never died. Each autumn I take cuttings, and though they are confined to a few flower pots, when I look at them I see the past. Other colours change. The grass is not the green of my youth. Nor the blue of the Italian sky. They are in flux. But the red is constant. In the evolution of colour red stops.

Red is rare in the landscape. It gains its strength through its absence. Momentarily, in an ecstatic sunset, the great globe of the sun sinking below the horizon . . . then it's gone. I've never seen the legendary green flash. Remember, great sunsets are the consequences of violence and cataclysm, Krakatoa and Popocatepetl.

I blink, there's Red Riding Hood in the dark forest. A bright red cloak in the gathering gloom. The red-eyed wolf licks its scarlet chops.

PAINTERS USE RED LIKE SPICE!

'Never trust a woman who wears red and black,' says Robert's Victorian mother. But should we trust a Red Coat either? We might be at the other end of his musket.

That most secret and coveted of places, my mother's dressing table, a shrine to Aphrodite, the rosy one – scarlet lipstick, delicately scented, rouge, and bright red nail varnish. I stumble around the room in the ruby slippers – they're too big for me. I'm no Cinderella. Forget the Land of Oz, I'm in *The Women*! Jungle red . . . the smell of fixative and pear drops. I admire my mother's dexterity. Red lips, cheeks, fingernails – which I help her to paint. The varnish gives you a high. I try painting my own nails and get caught in a fiery row. I'm the scarlet Whore of Babylon dancing in the Hanging Gardens. My father shouts at me, red in the face, 'Oh why doesn't he just . . . Fuck me! He's fucking me about!'

> Rose Red cannot be put in contrast with even the rosiest of complexions without causing them to lose some of their freshness. Rose Red and Light Crimson have the serious disadvantage of rendering the complexion more or less green.

> (Michel Eugène Chevreul)

In the 1960s, Mary Quant betrayed red with a blue lipstick which brought the shadow of death to many a lip. Red has its place. Lips are ruby. Blue lips make me shudder. Colour has its boundaries, though we are pushing at them. Imagine a blue geranium. They are imagining a blue rose – which will be a contradiction until the end of time. He bought me a dozen blue roses to declare his love! One cannot bring a message of love in the blues . . .

The Red Sea heals, crossing it causes a transformation, a baptism. The exodus from Egypt was a flight from sin. The Red Sea brings death to those who are unconscious, but those who reach the other side are reborn in the desert.

34

Christmas 1953. Heavy cabin trunks covered with stickers –
P&O. Hauled by porters. The excitement boarding the great
liner in Liverpool to sail to India. The journey took us
through the Bay of Biscay, sick as dogs with a hurricane
blowing, all the decks battened down.

The first stop the rock of Gibraltar, then across the Mediter-
ranean and the skies turned blue. Port Said, conjurers and
miracle-working gully-gully men, elaborate gifts from Simon
Artz. Down the canal to the Bitter Lakes, on our left,
Arabia Felix, home of the Phoenix. The ancient Egyptians
regarded the sea as untrustworthy, the home of the dark god
Set, Typhon, a place of storms. We sailed one evening into
the Red Sea, in a calm sunset, flushed pink and red. I took a
silver ball off the Christmas tree and tied it to a cotton reel,
lowering it into the wake of the ship where it sparkled across
the waves, red sails in the sunset.

Red sky at night, shepherd's delight. Red sky in the morn-
ing, shepherd's warning.

Red, Red, Red. The daughter of aggression, mother of *all*
colours. Extreme red, the colour of brigades and flags,
marching Red, Red on the borders and fringes of our lives. I
saw that when I lost my innocent eye. Red filled the intervals
between the musical notes, was a rousing anthem, 'Onward
Christian Soldiers' and 'The Internationale'.

I did not paint the town red until I was in my twenties. Then
I lost myself; as you went to bed, I took off to the Red Light
district of Soho. Our queer world was imprisoned in
shadows. Not the shop windows in Amsterdam or Hamburg
where the girls flaunted themselves in the red light. Red Hot
Mammas! Scarlet Women! In our world the flashing red light
warned us that there was a police raid. Caught red-handed,
we waited for hours carrying a number like a lottery ticket
before we were questioned and checked out. Red-tape.
Home alone again. Red hot with anger. These nights cost

you, the bank statement hovered towards the red. I sacrificed time and money pursuing red hot sex, which the legislators had made so difficult to find. I left books unread, and pictures unpainted.

ARTISTS! If you wish to paint red herrings these are your colours:

The Queen of reds is VERMILION. Cinnabar. Mercuric sulphide. *Sanguis draconis* (dragon's blood), the alchemic uroboros, the dragon of the philosophers. Found as a natural mineral and also produced artificially. In antiquity it was mined in Spain. There are numerous medieval recipes. Artificial vermilion is identical to that found naturally – but the price is not! 250 grammes of the artificial are £10, and the natural, for the same weight, are £250.

Vermilion is a red with a feeling of sharpness, like glowing steel which can be cooled by water. Vermilion is quenched by blue, for it can support no mixture with a cold colour. The glow of red is within itself. For this reason it is a colour more beloved than yellow.

(Wassily Kandinsky, *Concerning the Spiritual in Art*)

ALIZARIN CRIMSON, rose madder, is a natural dye from the root of the madder, *Rubia tinctorum*. It is the 'Rubia' of classical writers, the red of the Turkey carpet. It's one of the most stable of all natural dyestuffs. Rose madder was introduced from the East by the Crusaders to Italy and France, where it is known as La Garance; and gave its name to the guarantee, as its price was fixed – controlled by government.

RED LEAD. Red tetroxide of lead, the classical *minium secondarium* or 'sandarach'. Gave its name to the miniature. It is the colour of red letter days in a medieval manuscript.

These days it's used as a rust resistant more than an artists' pigment.

VENETIAN RED. Natural oxide of iron. Used as a warm ground in Venetian paintings.

CADMIUM RED, cadmium sulpho selenide. A late arrival. Cadmium red was first used as a pigment at the start of this century.

Red is the most ancient of colour names from the Sanskrit *rudhira*. The face of the Sphinx was painted red.

Ellsworth Kelly. Painter of Red.

The child of fire is the child of disobedience. In revolt. The Promethean child steals the matches to strike a dangerous light in the dark. As he sets fire, he has wicked thoughts. He will not get caught. The fire dies down. In the red embers he becomes aware.

Red is a moment in time. Blue constant. Red is quickly spent. An explosion of intensity. It burns itself. Disappears like fiery sparks into the gathering shadow. To warm ourselves in the long dark winter when the red has departed. We welcome the robin redbreast, and the red berries that sustain life. Dress in the Coca Cola red of Father Christmas, the bringer of gifts. We sit around the table and sing 'Rudolph the Red Nosed Reindeer' and 'The Holly and the Ivy'. 'The holly bears a berry as bright as any blood.' Our winter faces are dyed a cheerful red. We preserve the red like a flame. Life is red. Red is for the living, but the scarlet berry of the yew poisons, keeps the devils at bay in the churchyard.

Red memory. The first Adam formed by God from the red soil was a red man. Was it the dark red soil of the Nile flood that gave its name to Egypt, the land of Khem? The Arabs

gave us the word *al-kimiya*, out of which grew our scientific chemistry. Lost in the scientific labyrinth we pray for Ariadne to rescue us with a red thread.

Four stages are distinguished in alchemy: MELANOSIS (blackening), LEUCOSIS (whitening), XANTHOSIS (yellowing) and IOSIS (reddening).

It is in these colours that the modern pharmaceutical industry was born. The great dye factories experimenting in scientific and artificial colour in the nineteenth century. The invention of malveine, aniline, fuchsin, the red dyes, were the foundations of Bayer and Ciba, and many other multinationals. Colour was turned into explosives. The fiery orange of nitre. Not only were they making explosives but they were also making drugs. The pills you swallow came from the dyers' works. In antiquity, colour (*chroma*) was considered a drug (*pharmakon*). Colour therapy.

Red may have been purple in antiquity, as the Greeks had a very different conception of colour to ours. For instance they had no word for true blue. Was Clytemnestra's carpet purple, or was it crimson? Was the imperial purple, in fact, red? Let us believe that Clytemnestra wove a crimson carpet for Agamemnon – blood red with a touch of blue in the blood. When he stepped on this first red carpet he committed the sin of hubris, and was murdered. Red carpets lead to assassination. Revolutions die in their own red. Have you ever stepped on a red carpet? Felt the pomp and circumstance? Before it was pulled from under your feet? Red betrays.

Red Spots and Planets.

Red is the colour of Mars. The bloody god who rides into battle on a red lion. It is his red that Saint George carries on his cross. The red cross of the Crusaders who carry their heraldic banners in Gules and bloody Sanguine. Back home

they picked the red rose of Lancaster and fought the white rose. Red Russia, white Russia? The red one, the winners in a lost battle.

> Tudor indeed is gone and every rose
> Blood red blanche white that in the sunset glows
> Cries blood blood blood
> Against the gothic stone of England . . .
>
> (Ezra Pound, *Cantos*)

We put on Red Coats, and died in red hospital blankets, concealing terrible wounds. But Mars is put to flight by that other red, the Red Cross. The red Christ of sacrifice. The son who is the red of the Trinity. The blood of whose sacrifice burns in a thousand red votive lights in the gloom of churches.

Each victory of the red cells brings death . . . for the virus is red. This dance of death. Red plague cross. Red as a scarlet fever – the smallpox. Red has always embraced the hospital. The tenth-century physician, Avicenna, dressed his patients in red clothes. Red wool tied about the neck protected. Like for like. Colour could cure. Red moved the blood. Avicenna made medicine from red flowers. If one gazed intently at red the blood would flow. This is why you should never let a person with a nose bleed see red. Celsus plastered wounds with brightly coloured plasters; of the red plasters he writes: 'There is one plaster almost of a red colour which brings wounds very quickly to cicatrise.' Edward II had a room entirely decorated in red, to ward off the scarlet fever.

Red Stop Red Stop Red Stop Red . . .

I'm coming back from the blast furnace of St Anthony's fire, an eczema which turned me red. Violent red soreness. I turned almost purple. My skin no longer welcomed the world, but shut it out. I was in the solitary confinement of

39

the senses. For two months I could not read or write. Work stopped on this book. The red eczema spreads across my face. 'Where have you been on holiday?' passers-by asked. A short stay in hell.

Nature, the unnatural Red in tooth and claw
Out to destroy me.
In the good old days you went mad.
I've kissed the scarlet lips of insanity
And sent him on his way.

Red hair was associated with evil. Red-haired men were considered the devil's progeny. William Rufus, li rei rus, who was killed in the New Forest on Thursday, 2 August 1100, was a sacrificial king, remembered as a tyrant so black he is painted red. Unspeakably depraved. His red, the colour of blood, the devil himself and the flames of hell. Queer King Rufus. The last in a long line of sacrificial gingers! David, a real gingerbits, chuckles nervously as he types this into the word processor. There is a full moon in Dungeness tonight!

Of the medieval humours, choler (anger) was hot-blooded and red:

> . . . reddish colour shews blood, but fiery, flaming, burning hot, shew choller, which by reason of its suitability, and aptness to mix with others, doth cause divers colours more: for if it be mixed with blood, and blood be most predominant, it makes a florid red . . .
>
> (Heinrich Cornelius Agrippa, *Three Books of Occult Philosophy*)

Red with anger, they proclaimed the Revolution. Red Phrygian caps thrown high. The scarlet neckerchiefs of Garibaldi. 'Liberté! Fraternité! Egalité!' Viva la libertà! Blood, the guillotine and old women knitting scarlet. Social red.

Red rags to John Bull.

Liverpool. Early 1980s. I join the march. V. (REDgrave) says, 'Derek, you carry a red flag.' There are fifty of us. The ghostly galleon of revolution past. We march through the deserted and derelict city with the sound of the wind whipping through the flags, a rosy galleon on the high sea of hope. The sunlight dyeing us red. Shipwrecked on the last coral-reef of optimism. Someone says to me, 'The red of the square is beautiful. The root of the red is life itself.'

As we march, the red-necked gentlemen of England, in hunting red, are sweating away their Saturday afternoon chasing the red fox. But our eyes are focused on Lenin's tomb. The tomb of the Revolution. Its proportions as fine as the Parthenon, in red granite. High above it on the Kremlin a great red flag flutters, even on days without a breath of wind, as the flagpole hides a wind machine to keep the flag flying. Someone else says, 'The Spartan army was dressed in red wool, with red-leather shoes. This is an old march.'

RED CARDINALS BETRAY . . .

We came to alter the world, not join it,
Curse all assimilationists,
Burn the blue out of Britain,
Curse ALL closeted queers,
Throttle government with red tape,
Curse ALL theatre queens,
Set the red devils free in the palace,
Curse ALL those who dance the night away,
And do nothing but sleep through the daylight.
Drive the banks into the red.
Proclaim hell on Earth!
Throw red bricks through grey windows.
Scorch Heaven,
Celebrate your Red Letter Days . . .

The red shoes which Judy Garland clicks together, making her wish in the Land of Oz, bring GOOD LUCK – for they transport her home to Kansas. But the red shoes of Michael Powell's film dance Moira Shearer to her death.

In 77 BC, at the cremation of Felix, a Red charioteer, a supporter threw himself on the funeral pyre. The supporters of the Whites said he was 'out of his mind'. But you should have seen Felix!

Wasn't Dorian Grey's brain speckled with the scarlet stain of insanity?

I post a letter to you, dear reader, in a red Italian envelope in the little red pillar box at the end of the garden, and watch the postman collect it at four pm in his red van. Italian business envelopes are always red. URGENT, they say. Our brown ones sneak in unnoticed.

I wrote this book in an absence of time. If I have overlooked something you hold precious – write it in the margin. I write all over my books, as markers fall out. I had to write quickly as my right eye was put out in August by the 'sight oh! megalo virus' . . . and then it was a run-in with the dark. And dark always comes after light. I wrote the red on a hospital drip, and dedicate it to the doctors and nurses at Bart's. Most of it was written at four in the morning, scrawled almost incoherently in the dark until sleep blissfully overtook me. I know that my colours are not yours. Two colours are never the same, even if they're from the same tube. Context changes the way we perceive them. I've usually used one word to describe a colour, so red remains red with lapses into vermilion or carmine. I've placed no colour photos in this book, as that would be a futile attempt to imprison them. How could I be certain that the shade I wanted could

be reproduced by the printer? I prefer that the colours should float and take flight in your minds.

Derek.

P.S. To be red is to have a colour, not a look. Of course an object may look red for a while, like the Parthenon in the dying rays of the sun.

The Romance of the Rose and the Sleep of Colour

When Adam delved, and Eve span, who was then the gentleman?

The long sleep of Aristotle descended on the Middle Ages. Colour went on a Crusade, and came back with strange heraldic names: Sable, Purpure, Tanne, Sanguine, Gules, Azure, Vert, on a host of fluttering flags.

For a thousand years Aristotle was the Master of Scholastics and as these years passed this philosophy hardened into a system. A dogma which put an end to speculation – as late as the 1590s teachers at Cambridge could be fined five shillings for any thought that contradicted his writing. Aristotle threw a shadow across the Middle Ages. A pall of hush.

As the Roman Empire collapsed, iconoclasts waged war against the graven image. Colour became the fount of impurity. A chasm opened up between the terrestrial and celestial world. The dog chased its tail to bite it off.

Statues are unclean and loathsome spirits.

The divine will is invisible. The art of men material.

Under this assault artists slid down the snakes to become artisans. No Phidias or Praxiteles now.

Nobody is that mad to believe that the shadow and the truth are the same substance.

(Theodore of Studion)

45

The question was, who moved the hand that held the brush or chisel? How could we be certain this image of an eye was the eye of God, not the imperfect invention of misplaced inspiration?

In spite of these attacks the artisan artists were not driven out of work. St Gregory believed that painting had a purpose, to educate, it could be redeemed and forgiven. As propaganda it was useful.

When you look at medieval paintings bright with gold and keen clear colour you cannot remain unmoved. It's not until our time that colour sparkles in the colour fields of contemporary American painting with this strength and purpose.

To gaze on this rich gift must have had the shock of a laser.

The dun-coloured world of serfdom, transformed to a cornucopia that spilled the rainbow over the altar in the church.

> There sprang the violet all new,
> And fresh periwinkle rich of hue,
> And flowers of yellow, white and red,
> Such plenty never there grew in mead.
>
> (Geoffrey Chaucer, *The Romaunt of the Rose*)

The flowers Chaucer loved were the daisies, white and red, the primrose, and the violet, simple, wild flowers. His meadows are strewn with flowers, ecstatic and hallucinatory.

This poetic world is depicted in the unicorn tapestries hanging in The Cloisters in New York. A representation of the Hortus Conclusus, the white unicorn sleeps on the virgin's lap.

From the gardens of the *Romaunt* we walk into the Gothic

cathedral. The pointed vaults and flying buttress of Abbot Suger's St Denis, the foundations of which were laid on 4 July 1140.

The flying buttress made possible large windows filled with stained glass which reached its apogee in the Sainte-Chapelle, a dancing glass kaleidoscope.

Of the wall paintings, gilding, glass and hangings of St Denis Suger writes:

> The walls prepared and becomingly painted with gold and precious colours. The gilded doors were hung with this dedication. Marvel not at the gold, and the expense but at the craftsmanship of the work. Bright is the work, but being nobly bright. The work should brighten minds so they may travel through the true light.

The makers of his marvellous windows had a rich supply of sapphire glass and ready funds of £700.

Suger is practical, he offers English Stephen £400 for pearl and precious stone. £400 for the lot! 'They were worth much more.' The Saints are reburied clothed in copper and jewels and the altar cross completed.

> Now because the windows are very valuable on account of their wonderful execution and the profuse expenditure of painted glass and sapphire glass, we appointed an official master craftsman for their protection and repair.

> (Panovsky, *Abbot Suger*)

The men and women of this time, as the *Canterbury Tales* testify, were great travellers along the pilgrims' routes. Rome, Santiago, Walsingham and Glastonbury. Our picture

of the Middle Ages as a world of immutable serfdom is only partly true; the educated had Latin, a universal language. Some, like Mandeville, travelled from an easy chair in St Albans to the land of Prester John and Big Foot, and others back-packed in Marco Polo's footsteps to China to see the great Khan, by way of the great lapis mine on the banks of the River Oxus where that most precious of colours, ultramarine, was mined. The blue from over the sea which gave its colour to the mantle of the Queen of Heaven.

Roger Bacon (1214–*c*1292), born in Ilchester, Somerset, under hierarchies of angels showering their divine influences on the inferior world, had a mind with none of the boundaries of imagination of our time. The old sages might repeat themselves, but the story changed in the telling . . . in his *Opus tertium* he deals with the difference between speculative and practical anatomy. He writes of the elements and humours, and geometry, gems, metals, salts and colour pigments . . .

The Middle Ages set you adrift in an ocean of ideas which glow like phosphorescent plankton on its moody surface. It is another time where the clock ticks slowly with no end, but the millennium. A clock of days not seconds in which an illuminator had time on his hands.

They built as in Revelations
In jasper and jacinth
Emerald and Sardonyx
And lived like the swallows
That flew from the dark
Into the light of the mead hall.

To understand the passion for gemlike colour, look at the illuminated manuscripts – the passing centuries rubbed the colour off old walls, but in the manuscripts hidden from the light that creates and destroys, you can see colour bright as the day it was laid down by the illuminator.

In the chalky world of Dulux and the colour chart, you remember colour was once bright and precious. There is not a drop of vermilion or ultramarine, congealing today in these rusty cans. If the Scarlet Whore of Babylon was painted with these house paints you would not notice her, but in a Book of Hours she would flame like the sunset.

Grey Matter

We're starved of technicolour up here . . .

'Grey is void of resonance,' says Kandinsky, 'an inconsolable immobility.'

> He sat in the wheeled chair, waiting for dark,
> And shivered in his ghastly suit of grey,
> Legless, sewn short at the elbow.
>
> (Wilfred Owen, *Disabled*)

The achromatic grey scale shunts from black to white, the greys measured in the light they reflect.

'The shadows of black cast on white.'

Ostwald invented the grey scale at the turn of the century.

The detuned television flickers grey, waiting to be flooded with colour, waiting for the image. Grey has no image, is a shrinking violet, shy and indecisive, caught in the shadows almost unnoticed. You can travel from it to black or white. Neutral, it doesn't shout its presence. Unlike red, which creates noise on video, this detuned grey is a source of light, contradicting Wittgenstein's remark that 'Whatever looks luminous does not look grey'.

Shadow, said Augustine, is the Queen of Colour. Colour sings in the grey. Painters often have grey studio walls, for instance the grey-papered walls on which Géricault hung his paintings. Grey makes a perfect background. The walls of Matisse's studio were grey, but he ignored it, and trumpeted in the new century by imagining them red in his *Red Studio*

of 1911. In this painting the room and its contents are dissolved in scarlet – taken over.

Grey is tenacious, it allowed the high-key colour to rush over it into the future but retained a presence; in the paintings of Giacometti, who pared away the figure until it looked like the stroke of a pen; of Jasper Johns, who painted the American flag grey; the grey in Joseph Beuys who wrapped the world in grey felt; and Anselm Keiffer, who worked in the grey lead of alchemy. They were the inheritors of Renaissance grisaille, figurative paintings executed entirely in monochrome by the master of grey, Mantegna.

Remarkably few critics ever mention colour when discussing painting. Pick up any art book and look at the index. No reds, blues or greens. But critics wax lyrical over Mantegna's grisailles, they tell us with authority that these paintings are grey. *The Introduction of the Cult of Cybele to Rome*, in the National Gallery, painted in 1506 for Francesco Cornaro, sends them into achromatic orgasm. It allows them to describe 'colour' without getting into the bordello of the spectrum, the painting, grey except for a marbled background, antique figures modelled in three-dimensions with a Roman solidity. A *trompe-l'oeil* frieze of dignitaries receiving the tribute of the goddess, in the form of a stone omphalos.

Grey were the dismal rain-sodden days of my childhood. The depressions following, one after another, like a goods train to dump the misty waters of the Atlantic on my holidays. Rain rattling on the grey roof of the Nissen hut, ennui and boredom, I stared out of the window waiting for the sun.

To what degree the cloudy sky of northern climates may have gradually banished colour, may also admit of explanation.

(Goethe, op. cit.)

The clothes of my schooldays were grey, grey flannel shirts and suits. In the 1950s everyone wore grey, the purples and reds of the Coronation were enchanting – but we saw them in grey on our televisions. Everything had its place in a world ruled by grey, the porter at the station doffed his cap and said to the little grey schoolboy, 'Good morning, sir.' This grey would be dispelled in the 1960s by youth fashions, spawned from Cecil Gee's tomato and sky-blue drape jackets, worn with defiance by Teds.

Ash grey. Potash made the fine glaze for the pots we fired in the old brick kiln. Grey took on the colours of the spectrum . . . greenish, reddish glazes.

> Despise not the ash, for it is the diadem of thy heart,
> and the ash of things that endure.
>
> (Morienus, *Rosarium*.)

In the 1960s, all colour was swallowed in the *Götterdämmerung* of Pasolini's *Pig Sty* in which a naked business man, stripped of his respectability and his grey suit, runs through the desolate purgatorial volcanic ash. Ashes to ashes. Dust to dust. Lost in emptiness, all dreams and ambitions founder. Incarcerated in the dead lead coffin of illusion. The dream ends in grey. Dull, clouded, depressing, dismal grey. Penitential, sackcloth and ashes.

Grey surrounds us and we ignore it. The roads on which we journey are grey ribbons dissecting fields of colour. In the distance, the towers and spires of medieval churches and cathedrals, with their lead grey roofs, loom over village and town. Lichfield, the field of corpses. If they had colour it long since washed away. In the High Street banks, money is handled by little grey men, trustworthy in their uniformity, who put an ideal before self. Unthinking grey. The guardians of a grey area. Grey in their state of mind.

Present politics.

In grey days of spring
The colours sing in my garden
Grey days cool with mists.

At the edge of the horizon, behind the grey bulk of the
nuclear power station, lies the grey area of secrecy. Home of
the colourless atom, but grey in the mind's eye. The corner-
stone of the half-truth on which governments build their
defence, atomic half-truths which we live here. Nuclear
Electric monitor the radiation. 0.05 milli-sieverts per hour in
my kitchen. Though nothing is said about the gamma rays
from the inadequately protected Magnox A, running past its
sell-by date which was in the last decade. No one will give
you any answers unless you kick them in the shins. The
Berlin Wall may have been demolished, but it still runs
through our institutions. I'm told I'm living on the fringes of
society, but what if the world was awry?

I spent an afternoon in a silver grey wood, a dead wood on
the banks of the Mississippi. Its lunar atmosphere a pre-
monition. *Nature morte.* Lunatic. What colour is the hole in
the ozone layer? A grey area?

Wondrous this masonry wasted by Fate!
Giant-built battlements shattered and broken!
The roofs are in ruin, the towers are wrecked,
The frost-covered bastions battered and fallen.
Rime whitens mortar; the cracking walls
Have sagged and toppled, weakened by Time.
The clasp of earth and clutch of the grave
Grip the proud builders, long perished and gone,
While a hundred generations have run.

(Anon. Trans. C W Kennedy, *Old English Poetry*)

Can I think of grey writers? Possibly Beckett. Certainly

William Burroughs; the first in his work, the second in his presence. A gentleman in a pearl grey hat. Grey in the fortress and dungeon of sartorial elegance. Grey friar. *Eminence grise*.

> In dress we associate the character of the colour with the character of the person. We may thus observe the relation of colours singly, and in combination, to the colour of the complexion, age and station.
>
> (Goethe, op. cit.)

Old grey beard, Leonardo. Grey matter.

As I write, the little steam train of the Romney, Hythe and Dymchurch Railway rattles past, sending out plumes of grey smoke. The smell of fire and hot ash drifts across the landscape. The scent of my childhood, waiting for the train to take me back to school from Waterloo.

And we end in deathly grey.

The elephant is too large to hide itself, and the rhino too angry. The old grey goose will not become the silver fox's dinner. But the silver fox will become the rich bitch's tippet. Little grey moths are lurking in the twilight of her closet. As the old grey owl hoots all vanity turns to dust.

BOOK MOTH

A moth ate a word. To me it seemed
A marvellous thing when I learned the wonder
That a worm had swallowed, in darkness stolen,
The song of a man, his glorious sayings,
A great man's strength; and the thieving guest
Was no whit the wiser for the words it ate.

(Anon. *Old English Poetry*, op. cit.)

55

Grey is the sad world
Into which the colours fall
Like inspiration
Sparkle and are overwhelmed
Grey is the tomb, a fortress
From which none return.

Marsilio Ficino

The present is filled by echoes of past . . .

The angels play peek-a-boo from behind the throne of Masaccio's dumpy little Madonna in the National Gallery – now you see them, now you don't. Perspective smiles at you.

At the time Ficino was born, on 19 October 1433 under the melancholy sign of Saturn, the painter Uccello, possessed by Perspective, shut himself in his studio for days on end. His angry wife believed he had taken Perspective as a mistress – Perspectiva was one of those girls who stand at the vanishing point on the road south, stripped to the waist even on the coldest winter mornings, picking up the commuters.

Dame Perspective opened up the view.

Punched holes in walls.

Gave Uccello's world a new perspective.

The ruler of Florence, Cosimo di Medici, welcomed the new with open arms . . . his city prided itself on its modernity.

In 1439 the Byzantine Emperor John Palaeologus and an eight-year-old scholar Gemistus Pletho came from hard-pressed Constantinople to plead for help against the Moslem Arabs, and to initiate debate on the schism between the churches of the East and West. Pletho gave a vertiginous display of erudition lecturing on Aristotle. The audience listened with rapt attention, but they were much less happy with his second lecture on Plato and the Neoplatonist Plotinus. Plato was considered a spewer of demons – only a fragment of the *Timaeus* was known to the audience, otherwise everything was Greek to them – Platonic philosophy

smashed into Aristotelian scholasticism like a meteor into an iceberg, blasting the God of the Christ Rights with Saturn and Jupiter, Juno and Venus and the messenger Mercury. Could any of this be excused by the description of Plotinus as a humble and soulful man by his biographer Porphyry? Surely these were a bad lot.

Cosimo felt differently. In 1453, the year after Leonardo was born at Vinci, he had a brainwave – he would set up a Platonic Academy . . . but who would run it? Some years later this was resolved when he met Marsilio, the teenage son of his physician. Marsilio had been brought up as an Aristotelian and acquired a little Greek. Cosimo encouraged him to perfect the language and then commanded him to translate the hermetic texts, setting him up as master of the new school.

This decision opened a door in the labyrinth.

Plato, he discovered, was a revision of life – a Renaissance.

In the 1430s a fourteen-year-old boy could be burnt at the stake for an act of sodomy – this would not happen in Florence again. Platonism confirmed that it was right and proper to love someone of your own sex – a more practical way of viewing sexuality than the church's blueprint of DON'Ts. The modern world received the message with open arms and Botticelli, Pontormo, Rosso, Michelangelo and Leonardo stepped from the shadows.

I know this is a long way from light and colour . . . but is it? For Leonardo took the first step into light, and Newton, a notorious bachelor, followed him with *Opticks*. In this century Ludwig Wittgenstein wrote his *Remarks on Colour*. Colour seems to have a Queer bent!

All my friends live with limited civil rights in this Year of the Christ Rights, 1993.

We should remember Ficino translating Plato in the best Italian, 'young men taught by old masters to the point of love', though Porphyry denies that Plato had carnal intercourse with his students – it was love of kindred souls. The bisexual Lorenzo, Cosimo's grandson, was to take the fifteen-year-old Michelangelo into his household to educate him.

Ficino moved into the new Academy building and immediately decorated its walls with paintings of the antique gods and ancient philosophers. This gesture (Ficino prayed to them) spread like oil over water and by the end of the century we find painters steeped in the new classical learning, Botticelli painting his *Venus*, Mantegna *The Triumph of Caesar*.

Lorenzo swung both ways, but most of his pupils only had eyes for other men. The court embraced the sexual morality of the symposium. The church reacted, but slammed the doors too late at the Council of Trent which brought the counter-Reformation in 1548. By this time, the Sistine Chapel, a homoerotic hymn, enveloped the Papacy.

Ficino, the first 'therapist':

I summon all of you to nourishing Venus – and while strolling through all this greenery, we might ask why the colour green is a sight that helps us more than any other, and why it delights us. Green is the middle step in colouring and the most temperate . . .

(*The Book of Life*)

These are the rules for prolonging life.

Everything he writes is under the sign of the old gods, particularly his own melancholic Saturn, whose black bile brings sadness.

... when someone purges his eyes at that light (the light of God) he suddenly finds its splendour pouring in, shining grandly with the colours and the figures of things as the divine Plato says, a divine truth flows into the mind and happily explains all things that are contained in it ...

There are three universal and singular colours – green, gold, sapphire, and they are dedicated to the Three Graces.

Green, of course, is for Venus; and the moon, moist as it were, for the moist ones ... and appropriate to things of birth, especially mothers. There is no question that gold is the colour of the sun, and no stranger to Venus or Flora either.

But we dedicate the sapphire colour to Jove to whom the sapphire itself is said to be consecrated – that is why lapis lazuli is given its colour – because of its jovial power against black bile. It has a special place among doctors, and it is born with gold, distinct with gold marks. So it is the companion of gold, just as Jupiter is the companion of the sun. The stone ultramarine has a similar power, possessing a similar colour with a little green.

No wonder Ficino was not in favour with the church hierarchy. Jupiter stealing the blue mantle of the Queen of Heaven, and Venus spiriting away the green of the Eucharist.

The Christrights gasped, the colours stolen from under their feet, as the Neoplatonists flung themselves from the shadows. In a flash the dusty old scholastics were obsolete.

Ficino wrote his *Book of Life* one sunny summer in a meadow, al fresco, not shut in a cell. He was melancholic,

but his conversation was full of good-humour and laughter. He died in 1499 and soon his books were forgotten, but their effect on the history of ideas is incalculable.

Green Fingers

Were Adam's eyes the green of paradise?

Did they open on the vivid green of the Garden of Eden?
God's green mantle. Was green the first colour of percep-
tion? After Adam bathed his eyes in green did he look at the
blue sky? Or dive into the sapphire waters of the rivers of
paradise? Did he fall asleep under the Tree of the Know-
ledge of Good and Evil? Spangled with emerald dew. Love
was green then. When ancient Venus, old enough to be
God's granny, furious that she had been shut out of this gar-
den, materialised and touched Eve on the shoulder, causing
her to pick the apple-green fruit that led to her downfall.
Though, some have said, it was not an apple but an orange,
shining like the sun at hand's reach.

> She took of the fruits and ate. Then the eyes of
> both were open, and they knew that they were
> naked, and they sewed fig-leaves together and
> made themselves aprons.

Turfed out of the Garden of Eden for a snack by the un-
pleasant new God, they found themselves in a colourless
world. Remember them as you buy a dozen Granny Smiths.
There were few colours in the wilderness. At that time God
hadn't even sent a rainbow begging for forgiveness. If he
had, Adam would have returned it to the sender, for he
missed the colours of Eden . . . violet and mallow (mauve),
buttercup, lavender and lime. The serpent who lurked in
that tree was camouflaged green, khaki as the dust. This
green devil had other names. He was Pan who shook the
leaves with laughter, turning the nymph Syrinx to a handful
of reeds which sighed in the wind. In the old world any de-
lightful girl was in danger of becoming a tree. Apollo pur-
sued Daphne and she became a laurel. It's lucky the new

God didn't have a sex drive, as Adam might have been stuck with Eve in the form of a banana. Too late . . . Adam bit the fruit, and paradise, like all abandoned gardens, returned to the wild. A plague of greenfly invaded Paradise, the green parrot squawked abuse. Adam's sons developed green fingers to repair the damage, but every garden since has been but a leaf of paradise. 'Paradise' is the Persian for 'garden'. Each land worshipped green. The lotus columns of the Egyptian temples were painted Osiris green as were the acanthus columns of the Temple of Jupiter in Rome. This was to propitiate Adam's murder of green, when in a fury he hacked down the Tree of Knowledge to build the first house, and covered his cock with that fig-leaf. These gestures led straight to the dead grey of our city streets, which strangle the green parks like the old serpent.

When Xenophon brought us the word 'paradise' from the East, Praxiteles fixed an emerald on Athena's breastplate. Green brought wisdom. For instance, the tablets of Hermes Thrice Great were emerald. If the journey was long and difficult it could end in the Emerald City, or in the new Jerusalem whose walls were of green jasper, before the emerald throne of God.

'And there was a rainbow above the throne in sight like unto an emerald.'

Ten green bottles hanging on the wall, and if one green bottle should accidentally fall . . .

The history of gardening is the triumph of the green-fingered, accompanied by the laughter of sparkling fountains. The gardens of the Alhambra are crossed by the rivers of paradise. Gardens and groves are dedicated to the statues of the old gods and goddesses. Summer houses and temples to Venus are hidden in the green woods.

ET IN ARCADIA EGO.

'Green nourishes the soul.'

The old words of wisdom are repeated through the mazes and labyrinths of time.

> The conversation of old people should be under Venus in a green meadow. While we are strolling through all this greenery we might ask why the colour green is a sight that helps us more than any other.
>
> (Ficino, op. cit.)

Vitruvius says the space between the colonnades of a house ought to be embellished with greenery, for walking in the open air is very healthy, particularly for the eyes. Life is renewed in the green of spring, green is youthful and hopeful.

Nine green bottles hanging on the wall, and if one green bottle should accidentally fall . . .

The evergreen story continues. The teams at the circus have their colours – reds, whites, blues and greens. And emperors have their favourites. The Christian Theodoric supported the greens. Was this because green now symbolised Christian renewal? The green of the Eucharist? In this green the old gods were smothered like the babes in the wood. But other legends rode out of myth. The Green Knight comes to King Arthur's court, his hair and complexion green, riding a green horse, and carrying an axe of green gold. He commands Gawain to meet him at the Green Chapel at the spring solstice.

The Holy Grail was formed from an emerald struck from the crown of Lucifer by the archangel Michael . . . a green chalice.

The battle between nature and man was halted in the Dark

Ages as the woods claimed back the Roman roads and palaces. These woods were the home of the Green Man, whose lichen-covered face stares at you from a roof boss in the church. The Green Man moves slowly like the sloth, which is green with algae.

In the churchyard an evergreen yew, older than the church itself, presides over the livid green of the dead. Robbers lurk in the wood. Robbers who might do you a good turn. Robin Hood and his Merry Men in Lincoln green.

Eight green bottles hanging on the wall, and if one green bottle should accidentally fall . . .

In the fifteenth century Ficino translated Plato in the Platonic Academy, and initiated the Renaissance, which uncovered the old gods, rescuing them from the abandoned gardens, placing them back on their pedestals. The Neoplatonic garden reinstated the old polytheism, charting a path through the psyche in groves and arbours, terraces and temples. Here, pageants and parties, statues and fountains, conceits and practical jokes were set to music and fireworks. Greensleeves. Monteverdi. Years later, the painter Kandinsky who heard music in colours said:

Absolute green is represented by the placid middle notes of a violin.

Seven green bottles hanging on the wall, and if one green bottle should accidentally fall . . .

My first memories are green memories. When did my fingers turn green? In the paradisaical wilderness of the gardens at Villa Zuassa on the banks of Lago Maggiore? The April Gift of *A Hundred and One Beautiful Flowers and How to Grow Them* confirmed that at four my parents knew I was lost to green, as I walked down deep green avenues of camellias spotted with waxy carmine and white flowers. February

flowers that seemed more in keeping with the hottest of mid-summers. Lost in the woods of sweet chestnut I stared entranced at a pumpkin, with leaves as big as the fans that cooled the Egyptian pharaoh in a Hollywood epic. The cinema was born in a green wood.

Six green bottles hanging on the wall, and if one green bottle should accidentally fall . . .

In Rome, that freezing snowbound winter of 1947 with no fuel to keep us warm, my parents took me to see my first film. I was unable to disentangle the screen from reality, without distance, I cowered in my seat. As the house in Kansas was blown through the sky I bolted down the aisle and was brought back by an usherette drying my tears. For the rest of the film I sat in terror on my seat, staring wide-eyed as Lion, Scarecrow and Tin Man helped Dorothy brave the torments of the Wicked Witch on the Yellow Brick Road to the Emerald City.

'We're off to see the Wizard! The wonderful Wizard of Oz!'

My second experience of the cinema was even more frightening – Walt Disney's *Bambi*, in which nature is consumed by a raging forest fire.

Five green bottles hanging on the wall, and if one green bottle should accidentally fall . . .

Archaic green colours time. Passing centuries are evergreen. To mauve belongs a decade. Red explodes and consumes itself. Blue is infinite. Green clothes the earth in tranquillity, ebbs and flows with the seasons. In it is the hope of Resurrection. We feel green has more shades than any other colour, as the buds break the winter dun in the hedges. Hallucinatory sunny days.

I waited a lifetime to build my garden,
I built my garden with the colours of healing,
On the sepia shingle at Dungeness.
I planted a rose and then an elder,
Lavender, sage, and *Crambe maritima*,
Lovage, parsley, santolina,
Hore hound, fennel, mint and rue.
Here was a garden to soothe the mind,
A garden of circles and wooden henges,
Circles of stone, and sea defences.
And then I added the rust brown scrap,
A float, a malin and old tank trap.
Dig in your soul with the compost from Lydd,
Cuttings, divisions are placed in frames,
Protected from rabbits with neat wood cones.
My garden sings with the winds in winter.
Braving the salt which sails in plumes,
From the rolling breakers that gnaw the shingle.
No Hortus Conclusus, my seaside garden.
With poet's sleeping and dreaming of daisies.
I'm wide awake on this Sunday morning.
All the colours are present in this new garden.
Purple iris, imperial sceptre;
Green of the buds breaking on elder;
Browns of the humus, and ochre grasses;
Yellows in August on *Helichrysum*,
That turns in September to orange and brown;
Blue of the bugloss, and self-sown cornflower;
Blue of the sage and winter hyacinth;
Pink and white roses blowing in June;
And the scarlet rosehips, fiery in winter;
The bitter sloes to make sweet gin.
Brambles in autumn,
And gorse in the spring.

Huxley in *The Doors of Perception* perceives the 'isness' of
colour – that moment in time which stands still with Meister
Eckhardt:

The ivy fronds shine with a kind of glassy jade-like radiance. A moment later a clump of red hot pokers in full bloom had exploded into my field of vision. So passionately alive that they seemed to be standing on the very brink of utterance . . . lights and shadows passing with indecipherable mystery.

Not every one finds solace in green. The photographer Fay Godwin said to me last week that she was sick of photographing green – there's too much green in England! Dungeness with its ochre grasses and bone-bleached shingle came as a relief.

Four green bottles hanging on the wall, and if one green bottle should accidentally fall . . .

I present you with a green flower. No, it isn't Oscar's carnation. It's the hellebore, the Christmas rose; the petals of the flower are not true petals, like the hydrangea which can change its colour (from pink to blue, and back again – what would Aristotle have made of that?) and are the palest green. A true green flower is the flower of the tobacco plant.

Helleborus viridis, Green Lily or Fellon Grass, defies the elements, it flowers when all nature is locked in frost. Its seeds are eaten by snails and spread in their slime. It was used as a remedy for worms.

Where it killed not the patient, it would certainly kill the worms, but the worst of it is that it would sometime kill both.

(Gilbert White, *The Natural History and Antiquities of Selborne*)

These are some of the poisons in your hedgerow: Green Aconite, Cuckoo Pint and Woody Nightshade. Green's killing reputation . . . unlucky green . . . comes from another poison, arsenic, which produced emerald paint.

Apropos of that green carnation, Havelock Ellis was certain that queers preferred green to any other colour. Did they secretly drag up in all those emerald dresses that the girls had cast off? Hand a colour swatch to a lad with cock on his mind and see which colour he chooses . . . Priapus had a green one. Why were all those thespian rest rooms green rooms? And did you know Jesus was crazy about John, and John was the green evangelist? Perhaps there is a simple answer, too many young men stared for too long at those naked verdigris bronzes that obsessed the Greeks.

Three green bottles hanging on the wall, and if one green bottle should accidentally fall . . .

I'm playing the green glass bead game, Fast and Loose. There is a large green umbrella with which the peasants of Tuscany protect themselves from inclement weather. It is called a basilica, as it resembles the dome of a church. I first set my eyes on a basilica in a thunderstorm, location hunting with Ken Russell for his film *Gargantua* as we drove round the desolate back-lot at Cinecittà. I was describing my designs for the Abbey of Thelema. I was going to build it like the tomb of Hadrian, which had a wood planted on top of it echoing the Hanging Gardens. When the excited driver interrupted as a car passed us, 'Fellini,' he said. Both cars stopped, and after a pause a little man jumped out and opened a huge green basilica in the pouring rain and the bulky Fellini, hat cocked over his eyes, stepped from his car as elegant as a Fifties spiv from *La Dolce Vita*.

Two green bottles hanging on the wall, and if one green bottle should accidentally fall . . .

The Fifties. The fearful Cold War Fifties invented another green. This wasn't the green of birth, but an alien green, the colour of pus, the colour of rotting flesh. A green-eyed green that pounded on you in the pink and turned you sickly. Green around the gills.

Vomit and phlegm.

Under a viridian sky the goblins of science fiction material-
ised. The Mekon, and the slimy little green men from Mars,
making mischief in the light of a green cheese moon. Jealous
of us humans, they threatened. But wait! The Jolly Green
Giant and his friend the dragon are coming to the rescue.
Why are dragons green? Why are some lucky and others un-
lucky? Did George's slain dragon trace its ancestry to the
cold-blooded serpent, or perhaps further back to the dino-
saurs . . . which we assume, retrospectively, were green, but
could easily have been pink, purple or yellow.

Arsenic green was a most poisoned colour. Napoleon died
from arsenic poison as the green wallpaper in his prison on
St Helena rotted in the damp. He might have echoed one of
Wilde's last remarks: 'My wallpaper and I are fighting a duel
to the death. One or the other of us has to go.' Maybe the
angelica on his rice pudding was poisoned, or someone tam-
pered with the Crème de Menthe? I think it was a poisoned
greengage. A fruit discovered by Sir William of-that-name in
1725. Food was always a good method of delivering the coup
de grace. Mushy green marrowfat peas dyed a poison green
. . . A swig of green tea for the sophisticated . . . Popeye
runs amok with a murderous plate of spinach . . . Oh look, a
murderer is wearing that unlucky green dress! He stabs you
under the green light of the hottest star, while the merry
fairies dance the fairy ring. There you lie in the gutter as
gangrenous as Grunewald's flayed Christ – the rotting smell
of death in your nostrils.

One green bottle hanging on the wall, and if one green
bottle should accidentally fall . . .

'The owl and the pussycat went to sea in a beautiful pea
green boat.' Imagine they were red-green colour blind . . .
the sun sets green over a field of green poppies, maybe this is

where the owl and the pussycat go? Or maybe they were sailing to Mecca, into the spiritual green, and returned with the green turbans of those who made the pilgrimage. Memories of Scheherazade dancing in the emerald set of Bakst.

My Sixties were green. I discovered aerosol cans of a green as bright as grass, the aerosol was a new invention. I sprayed large canvasses with this, and divided the space with verticals in bronze paint which I mixed myself . . . 'Landscape with bronze poles'. Artists have always experimented, sometimes disastrously. Joshua Reynolds's use of bitumen turned his portraits a ghostly grey. Some colours faded, like the death of the copper greens in Venetian paintings, the violets that turned to white. The soot-black reds. Now they seem to be the artists' intention. Other colours, like the lapis blue, with which the Venetians painted distance, scream at you from the horizon as skies once painted in harmony almost fall out of the frame. It was this that led Caravaggio to say, 'Blue is poison.'

The most stable of the greens is Terre Vert. The most elusive, the copper greens that turned all Venetian paintings brown. Fugitive colour flies in time, and leaves us in a perpetual autumn.

Chrome green and permanent green are modern inventions. The dangerous emerald green is no longer manufactured. The under painting of many Renaissance paintings is green, which gobbles up the pink, so the face of Masaccio's Madonna has taken on the green hue of a ghost. She holds the tough little Messiah on her knee, while he reaches out to seize a bunch of purple grapes. She is sitting on a bishop's throne of marble, from behind which peeping perspective angels peer at us. There is no more maternal Madonna. What is maternal? Practical, perhaps? You can see that she could get angry with this child, and you can imagine her boxing its ears. She is not one of Raphael's or Botticelli's Parisian models, more a Page Three Girl with a green face, who

72

has to work hard at some other job. In spite of the mistreatment, her son could grow up a treat. Even though her husband Joseph is not his father and is not in the picture. Is this a one-parent family that contradicts all of the unattainable ideals? The one the Battenbergs ape so unsuccessfully – it takes a Queen to ruin family life.

I never saw the verdigris green charioteer of Delphi, a statue I imagined to be the most beautiful in the world. When I was eighteen I hitch-hiked there with some friends and was left a mile or two down the mountain road. Walking in the dark, we heard a small stream gurgling under a bridge and decided to stop and set up camp. We had been hiking since early morning, tired and dusty, with no money for a hotel or a youth hostel. We fell into a deep sleep a few yards from the road.

At dawn, we discovered ourselves in a cleft in the mountain. A chasm in which fig trees grew, watered by a crystal spring that sprang from the rock. We took off our clothes and washed them, hanging them to dry on the branches. Then bathed and shaved in the icy water, and sat in the warming sunlight waiting for our clothes to dry. At about seven, a rather angry visitor appeared, said something we couldn't understand and left scowling. Half an hour later, the silence was shattered by two police vans, from which a dozen or so policemen piled out, shouting. Confusion reigned as we couldn't understand a word they were saying. They furiously kicked our rucksacks, and threw our clothes in the dust, trampling on them. In our swimming pants we were very vulnerable.

David, who had climbed a rock face to get a clearer view of two eagles that circled in the updraft high above us, fell from his perch on the cliff face, and was saved from severe injury or even death by some rusty barbed wire at the bottom of the cliff which broke his fall. He lay bleeding and unconscious in a tangle of wire. The atmosphere changed, and we were bundled into the van, with the police siren blaring down to the hospital in Amphissa. There we were told never to return to Delphi.

We stayed in Amphissa several days while David recovered, his wounds painted scarlet with iodine. We learned that we had committed sacrilege. We had swum in the sacred well of Apollo, where the Pythian Priestess spoke her oracle.

I have always believed that this was my real baptism for the well brought the gift of dreams, prophecy. The ancients believed it was the fount of poetry. It was here they came for inspiration.

And before we leave green, let us pay homage to the nymph Chloris who has her hands twined in Flora's flower-strewn dress. Chlorophyll, the green of plants in the spring; the mint-fresh taste of green toothpaste, an invention of my boyhood; green Airwick; green Fairy Liquid; though, in a recent advert manufacturers of a white cleansing agent had it killing little yellow-green germs that had dropped from science fiction.

All games are played on the green. Games chart the soul, on the green of the terrestial stage. The cricketers played on the village green. Green in politics. Green in peace. I shuffle the cards on the green baize table. And under the green lamp shades I pick up a billiard cue.

> Such, such were the joys,
> When we all girls and boys
> In our youth time were seen
> On the echoing green.

(William Blake, *The Echoing Green*)

The distant lawnmower scents the air with green.

Green is a colour which exists in narratives . . . it always returns. The grass is always greener on the other side of the fence.

Alchemical Colour

Consider the world's diversity and worship it!

I stumbled into alchemy reading Jung's *Alchemical Studies* early in the 1970s. I don't know what made me pick it. Perhaps the fascinating illustrations of metals, kings and queens, dragons and serpents. I bought and read original texts, Dee's *Hieroglyph Monad and Angelic Conversation* (I used the name for my film of Shakespeare sonnets); *Cause, Unity and Principles* by Giordano Bruno; and Cornelius Agrippa's *Occult Philosophy*, a copy of which I found on a market stall for £5, a first English edition from 1651 missing only a few pages. The missing pages are restored and the book rebound. The British Library wants it – it's in far better condition than their copy.

Jung's work informed the poetry that I wrote for John Dee in *Jubilee*, particularly the final speech. The signature of flowers:

I signed myself with rosemary, true alexipharmic against your enemies.

These were the books that Prospero brought to his island. The Pimander and Orphic Hymns, Plotinus on the soul – *The Book of Life* (Ficino). *Conclusiones* (Pico della Mirandola), Paracelsus, Roger Bacon. *The Secret of Secrets*, a best-seller in the Middle Ages. Agrippa's *Occult Philosophy* and Dee's *Hieroglyph Monad*. *Shadow of Ideas* (1592), by Bruno who was burnt at the stake for heresy in 1600 in the Campo de' Fiori, Rome. The last great man to fall foul of the Inquisition.

It was believed that matter was animated by the soul, it took

science to do away with that. Lead, for instance, was saturnine and melancholic. Mercury, quicksilver, the mirror of life itself. Silver feminine, and Luna; Sol the sun, masculine and gold. Gold was the aim of the pursuit, fired by learning rather than greed. In this universe, everything had its place though no one quite agreed the order. The quest for the philosophic and incorruptible gold was a journey of the mind, the metal the mirror of the saviour.

The experiments bubbled away in the Balneum Maria – the cauldron named after Maria Prophetessa. In pelicans, the glass retorts with long spouts, the alchemist pursued his goal, unaware of atomic structure.

BLACK:
The base material was the Prima Materia, a chaos like the dark waters of the deep. Melanosis and nigredo.

WHITE:
The cleansing calcined albedo.

YELLOW:
Another stage, xanthosis.

PURPLE:
Iosis, the colour of kingship.

Pursuing the goal you crossed that Red Sea.

The peacock's tail *Cauda pavonis* was the iridescent rainbow that appeared in the molten metal:

> I am the white of the black and the red of the white and the citrine of the red.

Mercury was sovereign of the metals, it was both silver and red, it was the mirror and path to the Conjunctio. It was seen as the primordial water, guide and psychopomp. Since all

metals shared a soul, it could lead the way to the conclusion of the task.

The word alchemy comes from the Arabic *al-kimiya*, itself derived from the Egyptian *khem*, the name of the lower delta of the Nile. Its history stretches back to the Egyptian sages, adept in magic, the path of mortification, life, death and resurrection. This was an elemental world bathed in the influence of the stars and planets, where even time was ensouled in the decans.

Colours are kinds of light, all earthy colours such as black, earth, leaden brown have relation to Saturn. Sapphire and airy colours and those which are always green belong to Mercury. Purple, darkish and golden mixed with silver belong to Jupiter. Fiery flaming bloody and iron colour to Mars. Golden saffron and bright colours the sun and white curious green and ruddy colours belong to Venus. The elements also have their colours. They resemble celestial bodies in colour, especially Living Things.

(Cornelius Agrippa, op. cit.)

How Now Brown Cow

Poor demure brown.

Trampled by red.

Flies to the arms of yellow.

It confuses theorists. And is conspicuous by its absence in colour books. What is brown's kinship with yellow? Is brown mixed, as some have said, in the eyes? No monochromatic wavelength exists for brown. Brown is a sort of darkened yellow. Orange and brown, though of different intensity, have the same wavelength. Brown is compounded of black and any other colour.

> There are no physical stimuli for brown – no brown light. Brown is not in the spectrum. There is no such thing as a clear brown, only a muddy one.
>
> (Wittgenstein, op. cit.)

There are more browns than greens. The names of brown give us a clearer picture. The pigments are: earth brown; burnt umber; burnt ochre; burnt sienna; all earths cooked to red hot. Cooking is present in brown. Sepia is the odd one out – the ink of the cuttlefish, which was boiled with lye and used as a pigment.

Brown is an old colour. Its ancestors are the horses and bison painted in prehistoric caves. The clothes of our ancestors were brown. Most skins are brown. Brown cloth always dressed the poor.

The names of brown dyes are sweet and edible. You can buy a coat in caramel, toffee, almond, coffee, chocolate or curry.

Brown is sweetness and nourishment. There was once a colour called toast.

From the woods and fields came beige (unbleached wood), the expensive walnut veneers, the durable oak, chestnut (more for its colour than its wood), mahogany, tobacco and henna. Nigger brown, which waits to be reclaimed from political correctness, disappeared around my thirtieth birthday. In sanguine, the colour of dried blood, you almost cross into red. In buff there is death and slaughter. Buff is a buffalo hide. Donkey, the lowly beast of the Passion, is dun coloured.

Before the roads were asphalt grey, still dirt tracks, the dun-coloured earth turned to mud in the winter, and in summer to dust. Travelling was a filthy business. Perhaps that is why country coats were brown and city coats were black. I once heard a hundred-year-old man asked what the greatest change had been in his lifetime. He might have answered flight, television or radio, but he said it was the tarring of the roads. You can't imagine what it was like travelling before they were metalled.

The summer is over. The corn harvested. The fields are ploughed. The ploughman wears chocolate brown corduroy. Brown is the colour of riches. The man who owns acres is a rich man, both in pocket and hopefully in soul. For the soul is deep . . . a peaceful brown. However much you possess in life, even if your land stretches beyond the horizon, in death you will end up with six foot.

The woods and hedgerows turn the innumerable shades of brown from yellow to red. I ran back and forth in the dying light of October; catching the gold-brown leaves as they fell from the chestnut trees before they touched the earth and were swept up into the bonfire. Each leaf caught in the air brought you a lucky day. They floated slowly in spirals, as we threw sticks for the conkers, which we warmed in the

oven till they were as hard as stone, then fought each other bruising our knuckles.

Brown light?

> Unreal City,
> Under the brown fog of a winter dawn,
> A crowd flowed over London Bridge, so many,
> I had not thought death had undone so many.
> Sighs, short and infrequent, were exhaled,
> And each man fixed his eyes before his feet.
>
> (T S Eliot *The Waste Land*)

The autumn leaves dissolve in the mist and winter rain. Slow as a tortoise. It was on a tortoiseshell lyre that Apollo played the first note. A brown note. From the trees came the polished woods to make the violin and bass, which snuggled up to the golden brass. In the arms of yellow, brown is at home.

Brown is warm and homely. Simple and unrefined. Brown sugar, brown bread and brown eggs, which tasted so good that children fought for them. Until the supermarkets packaged them.

Hot crusty bread. Tea and toast, and yellow butter. Biscuits. Chocolate biscuits. Brown gravy and tart HP sauce. Chutney, and preserves cooking on the stove.

There is nostalgia in brown. The touch of my mother's soft beaver lamb coat in which we buried our tears. Brown simplified life. The old ladies of Curry Mallet wore thick brown stockings and brogues, with nut-brown, weather-beaten faces they polished their furniture . . . and polished it again . . .

Dinner is served on the shining mahogany table. Smelling of bees' wax and lavender. It is Christmas. My friend Güta sits at the head of the table dressed in ebony silk. Her silver hair shimmering in the light of the blazing candles on the tree. The wax drips. We worry a fire might be started as the door is opened, and the flames gutter. There is mystery in the glowing wood of the table in which your face is dimly reflected. This table was polished by Güta's great grandmother; and the sideboard, which is even older, by her great, great, great grandmother, the mistress of a Danish king, who gave it to her as a Christmas present. It was made in Paris, and to this day the drawers slide shut with a little rush of air – they are airtight. I am eighteen. The reason I am here is that I'm painting upstairs in the attic that Güta has given me as a studio. My paintings are in the browns and greens of landscape. Dark and sombre, stone circles and mysterious woods. They are the ancestors of my garden in Dungeness. Time passes, and we change less than we imagine. Güta comes up to the attic with tea. She tells me the Chinese emperors jealously guarded colour. In the Ming Dynasty, only the emperor wore green. But in the Sung, he wore brown. There's power for you.

Christmas dinner ended with a struggle to crack the nuts. Hazel and almond, brainy walnuts and sleek Brazils.

Brown had its ceremonies in my childhood. One of them was to soak the leaf mould in which you planted bulbs. Tawny tulips that shed their skins, revealing snowy hearts. Snowdrops, crocus and hyacinth, hidden in a dark and cool cupboard under the stairs, and constantly watched for the first blanched shoots. Then they were brought into the light, the ivory turned quickly to green.

If I was ever bored, or browned off, I would go to the cupboard and watch the returning spring. The smell of damp humus, rich, slow, somnolent. Brown is a slow colour. It takes its time. It is the colour of winter. It is also a colour of

hope, for we know it will not be blanketed by icy snow for ever.

To keep me warm, my mother gave me a chocolate-brown blanket which I still have. It has a name tag – M D E Jarman, and it reminds me that I was christened Michael.

If I fell ill in the winter, all the old patent medicines were brown. Friar's Balsam, cinnamon lozenges and Dr Collis-Brown's Elixir laced with opium which advertised itself in the military exploits of soldiers in nineteenth-century India. It dispelled nervous stomachs before the battle. Collis-Brown was the last medicine you could buy over the counter which contained opium. Sticky brown, it brought such pungent dreams; unfortunately the Sixties discovered drugs, and publicised the secret . . . Collis-Brown had its opium removed, and no one wanted it after that! Everyone in the nineteenth century laced themselves with opiates – no wonder it was such a vibrant time.

> The day was departing
> and the brown air
> taking the beasts that dwell
> on earth from their labours.

> (Dante)

Post-war food was inadequate, so we were dosed with large spoonfuls of sticky brown malt, Virol and cod liver oil. A small queue of children assembled after lunch in the brown-dadoed pantry of Mrs Munger, a five-foot bundle of ancient brown . . . who, like Giles's grandmother, wore a hat as she cooked. A hat which looked as if she'd shot it. We swallowed our medicine, while Mrs Munger struggled with a cauldron of apple-brown sludge, complete with pips and core, which got in your teeth and were known as Mrs Munger's toenails.

Night gathers drowsiness, and sprinkles it over the dark
earth.

(Ovid, *Metamorphoses*)

In his study, lined with beige hessian, Donald, Güta's husband, works at an ebony desk, supported by golden griffins.
Next to him, an old aspidistra puts on its brown flowers.
Above him ageing photos of the antique, marble busts of
author and emperor. Donald introduces me to the classics.
Plinys Elder and Younger. Donald is the Clerk of the Convocation at London University. We often catch the train to
London together in the old wood carriages of the Metropolitan, which have 'Live in Metro Land' proudly engraved
on their brass door handles.

As I travel up to London University each day to study
English, History and Art History I dream of a young lad . . .
he is the brown of the earth, bronzed by the summer sun.
His nakedness clothed in summer. He comes all over his
chest, the come as white as the lime that sweetens the fields.
He falls into delicious sleep, while the meadow browns flutter through the grass around him.

A Franciscan would bless him.

A Brown Shirt gas him.

And a brownie would blush and tell no one she gave him a
kiss.

Brown is serious. The galleries of my childhood were brown.
Helen Lessore sitting on the brown velvet sofa in Beaux Arts
gallery looking like a Giacometti painted by Andrew Wyeth,
brown shoes, brown woolly stockings and brown and practical dress, rather like a school ma'am. On the walls behind
her, Auerbachs and Aitchesons and the odd Francis Bacon.
It was to this gallery I came as a schoolboy, catching my

breath as I climbed the staircase, an adventure into the real world of the grown-ups. I think Helen spotted my nervousness and made me feel at home. Art in those days was a very small affair, there were few galleries, no colour supplements, no coffee-table books, and no art market. It was much more home-spun and everyone knew each other.

Bees' wax brown. Spit and polish of the barracks. Parquet, brass, gilding and mahogany. Mahogany benches. Vast mawkish paintings, heavy gold frames, all of them second rate. Millais, whose talent barely survived his twenties. Moore's pastel virgins with their Greekish draperies, Alma-Tadema's mincing marble heroines. We walk through the galleries XXI and XXII, the roman numerals heavy above the doors until we reach an afterthought in some converted storage room with the white paint already grey with the neglect the English keep for the twentieth century. Here there is a poor little Gilman of a sad little lady drinking PG Tips in the greys of Camden Town. There are no Stanley Spencers and no trace of one of his nude self-portraits; after all the police raid book shops and theatres and we don't want them in a gallery. There is a yellow and green Sutherland of a tortured tree root that looks like a little detail blown up from *The Hareling Shepherd*, a Piper of a Suffolk church tower splodged and blodged. Good heavens, there's one of Francis Bacon's orange Mugwumps! Thirty years later it's all the same, except the Victorian paintings have become even uglier than when I was young.

The story of a Little Brown Bear. When Icarus fell from the sky, Phoebus Apollo burned Arcadia dry as a bone. He was in such a tiswas. And Jupiter, like George Bush in Florida, inspected the damage – counting the cost. There he set eyes on a nymph, one of chaste Diana's girls. Jupiter lusted after this bit of skirt, changed his shape to resemble the moon goddess, and ungallantly raped her ... he didn't bother to ask her name, which was Callisto. She did her best to repel his advances, but failed. Poor Callisto (god, she had a bad

time) was further tortured by Diana, who discovered her shame while they were skinny dipping.

All in all, it was a mess that would take a charabanc of British social workers to sort out. Everyone was after Callisto's cherry, even the hairy brown proletarian satyrs. But rank held them in check. However, Callisto's trials were not yet over. Juno discovered her husband's indiscretion, and tripled the misery by turning poor Callisto into a little brown teddy bear. All her once gorgeous areas were overwhelmed by thick brown hairs that no depilatory could touch, and her face that might have taken her to Troy or Hollywood grew a snout with sharp little teeth. Years passed, and poor Callisto skulked in the forest, when a hunter who happened to be her son stumbled across her (isn't this complicated?). He was about to kill her and turn her into a trophy when Jupiter intervened and turned her into the stars of the Great Bear, so she sparkled like diamonds.

Her story is almost as complicated as that of Marilyn Monroe. For diamonds and stardom are a girl's best friend. This tale was set to music by Cavalli in Venice late in the seventeenth century. His opera has everything; beauty; a Sapphic band; rape; a complete lack of understanding; jealousy; and a little brown bear. And it teaches us that the rich and the powerful, like George Bush, always make a mess of things, and the gods are unaccountable, like Mrs Thatcher, for the distress they cause.

The shyest of brown paintings is a small Madonna, no bigger than this book, which is framed in tortoiseshell in a quiet corner of the National Gallery. It was painted in the 1480s by Geertgen Tot Sint Jans, and is easily overlooked. You will see very little if you do not stop and peer into its twilight. The *Nativity At Night* is a miracle, for the subject until that time had usually been painted in a blaze of sunlit colour. Geertgen uses a buff-pink for the flesh, and a subtle bouquet of browns.

What light there is is a spiritual light, that comes in barely discernible rays from the child in the manger, at the head of which there is a host of pudgy little angels with Pre-Raphaelite hairstyles. At the foot of the manger the Madonna's blue robe has turned the inky black of night; the sky is the same colour seen through the door of the byre. On a distant hill, the shepherds' barely discernible shadows are minding a flock of gun-metal grey sheep. Above them, the angel Gabriel hovers in angelic and spectral white. While, down below, the ox and ass, almost unnoticeable in the shadows, worship the child. Geertgen conveys the colour of night with a brilliance I have not seen in any other painting – this is not possible in a photo, and might just be possible in film, though it would cost a fortune in lights to achieve the effect. The night in Hampstead is this colour. The trees turn inky. The moon glows white like the angel. The grasses are a spectral brown. The silver birches chalky-white, and every form is dissolved in shadows.

The Perils of Yellow

It's a hundred years since the Yellow Press invented itself in New York; warmongering and xenophobic, it fights for the yellow in your pocket. Cultural cuckold. Raving, betraying, mental.

The fetid breath of diseased Yellowbelly scorches the hanging tree yellow with ague. Betrayal is the oxygen of his devilry. He'll stab you in the back. Yellowbelly places a jaundiced kiss in the air, the stink of pus blinds your eyes. Evil swims in the yellow bile. Envious suicide. Yellowbelly's snake eyes poison. He crawls over Eve's rotting apple wasplike. He stings you in the mouth. His hellish legions buzz and chuckle in the mustard gas. They'll piss all over you. Sharp nicotine-stained fangs bared.

As a child I had a horror of dandelions. If I touched a *pis en lit* I would scream myself to sleep. The dandelions harboured the daddy long legs that rustled in my dreams. Mess a bed. Devil's milk pale. Piss mire. Shit a bed.

The milk-white sap bleeds, the yellow flowers turn brown in death.

Here comes the yellow dog, Dingo, chasing a brimstone butterfly on a sharp April morning.

Daffodil yellow. Primrose yellow. The Yellow Rose of Texas. Canary bird.

Rape and rattle. Yellow hot as mustard.

Ultraviolet reflects yellow strongly, so insects fall over themselves and hallucinate.

Although yellow occupies one-twentieth of the spectrum, it is the brightest colour.

Lemons were used by Venetian courtesans to bleach their hair in the sun . . . gentlemen preferred blondes! I painted a lemon yellow picture for my show in Manchester . . . *Vile Book in School* – that was the Yellow Press telling us about a child being brought up by a couple in a same sex relationship . . . the painting took longer to dry than any of its companions. The charcoal words written on it muddied it:

Dear Minister,
I am a twelve-year-old Queer. I want to be a Queer artist like Michelangelo, Leonardo or Tchaikovsky.

Mad Vincent sits on his yellow chair clasping his knees to his chest – bananas. The sunflowers wilt in the empty pot, bone dry, skeletal, the black seeds picked into the staring face of a halloween pumpkin. Lemonbelly sits swigging sugar-sick Lucozade from a bottle, fevered eyes glare at the jaundiced corn, caw of the jet-black crows spiralling in the yellow. The lemon goblin stares from the unwanted canvasses thrown in a corner. Sourpuss suicide screams with evil – clasping cowardly Yellowbelly, slit-eyed.

Was Van Gogh's illness xanthosis?

Yellow imparts violet to a fair skin.

In a corner the unbought paintings stacked under the bed – once kings weighed pictures in scales of gold. The sun boils in the sky, a can of chrome maggots.

Whistler painted the Grosvenor Gallery yellow for his exhibition. Painted the golden fireworks in nocturnes, while others laughed. 'Greenery Yallery Grosvenor Gallery.' Whistler was bitter – was he a bitter lemon? Lemon-faced? He dished out brimstone . . .

The executioner in Spain was dressed and painted in yellow.

For every yellow Primrose that commemorates Disraeli there is a Yellow Star. These are the stars extinguished in the gas chamber. (Old as the ghetto.) Jews were wearing yellow hats in the Middle Ages. They were condemned to yellow like thieves and robbers who were coloured yellow and taken to the gallows.

Park benches were painted yellow. Aryans sat apart, yellow with terror. An evil vision jaundiced by colour, mark of Judas. Yellow plague cross.

We sail with the yellow plague flag on a ship into the bladder-wracked waters of the Sargasso.

The yellow emperor of the Ming Dynasty sails in his saffron barge along the yellow river. A sage in orange robes tells him that yellow orange is the brightest colour, a deep yellow that is a medicine against the livid acid yellow of illness. Jupiter, King of the Old Gods of the Far West, dressed in yellow, so did Athene, Goddess of Wisdom.

Black and yellow sends a warning! DANGER, I am a wasp – keep your distance. The wasps circle the Burger King, McDonalds and Pizza Hut, fast convenience food lettered in livid 'Jump At You' typography – black and yellow, red and yellow.

Yellow lines the kerbside. Yellow earth-moving equipment with flashing yellow lights, cutting a wound in the landscape.

> The yellow fog came creeping down
> The bridges, till the houses' walls
> Seemed changed to shadows.
>
> (Oscar Wilde, *Impression du Matin*)

A yellow memory from the yellow age. Fool's yellow, and yellow silence. When yellow wishes to ingratiate it becomes gold.

We drove from Curry Mallet through country lanes to Bristol, leaving the golden harvest, farm dogs catching mice as we progressed to the centre of the field, cutting back the corn. In the hospital in Bristol we had injections to ward off the yellow fever. That turned us sick. I nursed my throbbing arm for days.

I missed my summer holiday in York General Hospital on a fat-free diet – dry toast and yellow sponge pudding. Canary pudding. Pretty as a picture with bright yellow jaundice.

Yellow is more akin to red than blue.

(Wittgenstein, op. cit.)

Yellow excites a warm and agreeable impression. If you look through a yellow glass at a landscape the eye is gladdened. In many of the shots I took at Dungeness for *The Garden* I used a yellow sky filter on my Super 8. It produced autumnal effects.

A golden colour appears when what is yellow and sunny gleams.

The nimbus of the saints, haloes and auras. These are the yellows of hope.

The joy of black and yellow Prospect Cottage. Black as pitch with bright yellow windows, it welcomes you.

Yellow is a combination of red and green light. There are no yellow receptors in the eye.

If you mix paints you will be unable to mix yellow, though the oil you use is golden. Yellow sands. Yellow streak.

These are the pigments:

The modern yellows: barium yellow, lemon yellow... stable in light and invented in the early nineteenth century. Cadmium yellow, sulphur and selenium. The modern production of cadmium pigments began during the First World War. Chrome yellow. Lead chromate darkens on ageing. The yellow of turmeric sunsets.

Cobalt yellow, mid-nineteenth century. Too expensive. Zinc yellow, 1850. The old yellows: gamboge – a gum resin from the earth, that came with the spice trade. It leans towards orange.

Indian yellow, banned. Cows were poisoned with mango leaves and the colour was made from their urine. It is the bright yellow in Indian miniatures.

Orpiment poisonous arsenic sulphide. Brilliant lemon yellow used in manuscripts and mentioned by Pliny. It came from Smyrna and was used in Egyptian, Persian and later Byzantine manuscripts. Cennini says it is really poisonous, 'Beware of soiling your mouth with it lest you suffer personal injury.'

Naples yellow, lead antimonate, varies in colour from pale to golden yellow. The yellow of Babylon. It is called giallorino. It lasts forever, and is manufactured from a mineral found in volcanoes.

Spring comes with celandine and daffodil. The yellow rape sends the bees dizzy. Yellow is a difficult colour, fugitive as mimosa that sheds its dusty pollen as the sun sets.

Clouded yellows. Butterflies. Brimstones flying fast along the lanes in the spring sunlight. Yellow stone.

I wandered lonely as a cloud that floats on high o'er dale and hill, when all at once I saw a crowd, a host of golden daffodils . . .

Why not yellow?

What is the kinship of yellow to gold?

Silence is golden, not yellow.

Golden rod is without doubt yellow.

Gold dog Dingo could be a relation of the Yellow Labrador.

Yellow oldies and anniversaries.

Lemons
Grapefruit
Lemon curd
Mustard
Canary bird.

This morning I met a friend on the corner of Oxford Street. He was wearing a beautiful yellow coat. I remarked on it. He had bought it in Tokyo and he said that it was sold to him as green.

The caged canary sings sweetest.

Orange Tip

'Oranges and lemons, say the bells of St Clements,
I owe you five farthings, say the bells of St Martins . . .'

Where yellow dives into the red the ripples are orange.

Orange is optimistic. Warm and friendly – it suffuses the saffron sunset.

This warming orange is the colour of the robes of Buddhist monks and Christian confessors. It is the colour of maturity.

Marigolds are placed on the altars to ancestors on the Mexican Day of the Dead. A joyful Day of Remembrance.

Orange is the colour of abundance and plenty. It gives delight and enlightens. Turner streaks his skies with chrome orange.

Orange is a newcomer. Cadmium and chrome orange were discovered in the early nineteenth century.

Mary Magdalene brushes her orange hair. Jupiter watches in his orange robes. Orang-utans fly through the citrus groves chasing orange tip butterflies. Salamanders sink into sulphurous volcanoes somewhere beyond the Orange Free State.

What came first?
The name or the fruit?
Naranga, *za Faran* the saffron. The Spanish name for the orange was lemon citron.

Seville oranges, bitter for marmalade, buy them in a few short weeks in January.

Jaffa Sunkist Outspan from warmer climates.

The tangerine gave its name to a colour. Satsumas and clementine did not.

The orange is a source of vitamin C. The carrot vitamin D. Makes light of the dark. Bomber pilots ate them before flying on sorties.

The spices saffron and turmeric are orange. The saffron crocus from the Middle East was smuggled here in the Middle Ages in a hollow silver cane and grown in Saffron Walden. Its stamens collected to make the saffron Easter cakes. To experience the warmth of orange, look at it cupped in a purple crocus where the stamens glow bright.

> Orange is too bright to be elegant. It makes fair complexions blue, whitens those which have an orange tint and gives a green hue to those of a yellow tint.
>
> (Chevreul)

Leonardo

... a luminous body will appear more brilliant in proportion as it is surrounded by deep shadow ...

(Leonardo da Vinci, *Notebooks*)

I never warmed to Leonardo's painting. It looks like the children's TV series *The Chronicles of Narnia*. His portraits stare at you, strangely metallic, faces a little too beautiful or ugly. The smile of medieval statues grafted on to the bullet-proof *Mona Lisa* – and the sub-aquatic *Virgin of the Rocks*. I nearly said 'On the Rocks', you have to put on a snorkel to view them in their green sickness. His patrons were none too pleased either, not with the work, but the promises and long delays – and the experimenting, which had the *Last Supper* fall to pieces in a lifetime.

These paintings are but a shadow compared with the exquisite notebooks; in them Leonardo's theories of Light, Shade and Colour are the most perceptive since antiquity.

Leonardo was born in 1452, and as a child, Vasari tells us:

... he painted a dragon on a shield, and for this purpose he carried into a room small crickets, serpents, butterflies, grasshoppers, bats and such like animals, out of which he formed a great ugly creature ...

Leonardo's curiosity to examine the natural world is his gift. He wrote of nothing he had not observed.

As a young man Leonardo had a swishy dress sense, great beauty and the gift of the gab. He was ambitious, 'a disciple should surpass his master', he left his master Verrocchio trailing behind after five years as an apprentice.

He liked rude boys who stole, rough diamonds, like Salai who came as an assistant at fifteen and stayed for life.

Leonardo's sex life was active and open enough for complaints by outraged citizens.

Michelangelo, his great rival, was one of those Queers who fall for straight boys – a self-inflicted loneliness which he displaced with guilt and the love of God:

> . . . if to be blest I must accept defeat, it is no wonder if alone and nude I am by one in arms (a pun on the name of his beloved Tommaso Cavalieri) chained and subdued . . .

> (Michelangelo, *Sonnet*)

Women's bodies in Michelangelo's art are scrambled with weightlifters on steroids. Muscle men exhausted by the rigours of the work-out. Trapped in the stone they wage an unequal and endless battle to escape. The self-hatred of the flayed self-portrait in the *Last Judgment* – a deeply troubled spiritual journey to self-denial, and one of the greatest of masterpieces.

On the other hand, Leonardo's life was the life of a courtier. The grand artist who entertained and was entertained. He traded on his genius, and as the years passed grew a patriarchal beard, looking every bit like Neptune. Hair swirling around his face like the waters in the deluge drawings.

The notebooks abandon the old method of received wisdom for direct observation on perspective, colour, light and shadow, the art of painting, architecture, fortification, flight, a host of subjects.

His short pithy sentences mirror those of the philosopher Wittgenstein in our century:

The colour of an illuminated object is affected by that of a luminous body . . .

A shadow is always affected by the colour of the surface on which it is cast . . .

An image in a mirror is affected by the colour of the mirror . . .

No white or black is transparent . . .

Never had observation been so acute.

Leonardo changed the course of painting by his study of light and dark. He invented chiaroscuro which was taken up by Caravaggio in the next century. Leonardo describes the light illuminating the face of a woman in a darkened doorway:

Shadow is a diminution of light, darkness is the absence of light . . .

A luminous body will appear less brilliant when surrounded by a bright background . . .

The more brilliant the light, the deeper the shadows . . .

Leonardo is a light to the future. The past had feared clear-sightedness as if casting light on the shadows would send the Earth tumbling:

Since we see, the quality of colour is known by means of light – it is to be supposed that where there is the most light the true character of colour in light will best be seen.

In his marginal jottings we find information from the past:

Avicenna who will have it that soul gives body to soul, as body to body . . .

Roger Bacon, he mentions, and Albertus Magnus.

Leonardo dismisses the alchemists, 'the false interpreters of nature declare that quicksilver is the seed of metals' – alchemy leads to necromancy. This is even worse.

Diary entry, Saturday 2 March 1530:

I had from Santa Maria Novella 5 gold ducats leaving 450, of these I gave two the same day to Salai who had lent them to me . . .

And another entry:

I gave Salai 53 Lira and 6 Soldi, of which I have 67 Lira. There remains 26 Lira 6 Soldi . . .

With this money he bought:

Two dozen laces. Paper. A pair of shoes. Velvet. A sword and a knife. He gave 20 to Paolo, and had his fortune told for 6 . . .

The relationship with his assistant is a confirmed success as Leonardo leaves him a house and orchard in his will.

Queer moments – I once wrote a series of Renaissance comedies. Short films. *Pontormo's Unfinished Masterpiece*, *Michelangelo's Slave*, and *The Smile on the Face of the Mona Lisa*.

A Florentine banker commissions a portrait of his wife – she is a terrible chatterbox. Leonardo completes the portrait without the gossiping mouth. This is beyond even his powers, and she will not stop talking. Dreading her last visit

Leonardo is pleasantly surprised when a handsome boy comes to tell him his mistress has a bad cold. He sits the boy down and paints his smile on the portrait, and when it is finished he gives him a kiss.

Poor *Mona Lisa* has faded, drained of colour by time. Yet of all the paintings it has achieved the impossible. You can see her with your eyes shut. Vasari describes the painting:

> The eyes had that lustre and watery sheen that is always seen in life. Around them were touches of red. The lashes that cannot be presented without the greatest subtlety. The nose with its beautiful nostrils, rosy and tender, seemed to be alive. The opening of the mouth united by the red of the lips to the flesh tones of the face seemed not to be coloured, but living flesh.

In 1976, on my way to the Cannes Film Festival for the opening of my film *Jubilee* with Jordan, Princess of Punk and shop assistant at *Sex*, we took the morning off to visit the Louvre. Jordan was the spirit of the age. Photographers fought over her; she was on the cover of *Vogue*. Her spiky aureole of blonde hair worn like a crown of jagged glass splinters. Her new make-up, white face and one red eye with a Mondrian black line was world famous. Today she wore a knitted top in mohair with the word VENUS printed loudly across her bosom. She wore the shortest of white lace mini-skirts, acid green tights and very high stiletto shoes and looked like the young Victoria.

We passed the startled ticket collectors and tracked down the Venus de Milo, where I made a film of the charabanc parties being photographed with her . . .

EVERY WOMAN FOR HERSELF AND ALL FOR ART!

My filming was cut short by a zealous guard who bore down on us, putting his hand over the lens. We escaped to find the *Mona Lisa* in the Grande Salle. On the way the tourists pointed and whispered, taking surreptitious photos – and then the inconceivable happened, the tourists in this immense gallery forgot themselves and life became more important than art. Groups of Japanese turned their backs on the *Mona Lisa* and their cameras on Jordan. The hidden video recorded this for the guards and suddenly the walls of the gallery parted and we were arrested and hustled into a secret lift which whizzed us down to the basement, where an angry curator expelled us from the gallery for 'disturbing the aesthetic environment' – but I argued this lady is the most famous in the world, even more famous than the *Mona Lisa*. They shrugged their shoulders and we were marched to the exit.

Into the Blue

Blue light. A spectral light. Leni's full moon falling through a crystal grotto in the High Dolomites. The villagers draw their curtains against this blue. Blue brings night with it. Once in a blue moon . . .

Tacitus tells us of a spectral tattooed army, the Pictish Britons nude in the colour of the Ethiopians, Caeruleus. Dark blue, not the sharp blue from the paint tube.

The blue men of the High Atlas are dyed by the indigo sweated from their clothes.

Blue spaces and places. The Blue Nile, and the Blue Grotto. The grotto is lit by light that is refracted through the water from a small opening five feet high into a vast cavern. The ferrymen sing 'O Sole Mio'. The silent magic is broken.

Black blue sadness in Geertgen's *Nativity at Night*. The virginal blue robe which mirrors the blue sky is swallowed by black.

Gun metal blue. The patina of copper. Verdigris on the edge of green. Egyptian blue, a clear astringent colour that is the blue of the mosque. This is the blue of glaze.

In 1972, every wall in the studio was hung with blue capes. Everyone liked them, but no one bought them!

Blue blood is ruby.

Blue lies.

The blue-tail fly dances the blues in blue suede shoes.

The sky blue damselfly, iridescent, flits across the blue lagoon.

The blue Buddha smiles in the realm of joy.

Dark blue embroidered with gold.

There are gold flecks in the lapis.

Blue and gold are eternally united.

They have affinity in eternity.

The Buddha sits on the blue lotus supported by two blue elephants.

The blues of Japan. The work clothes, the blue of the roofs of its houses.

The blue work clothes of France. The blue overalls here in England, and the blue Levis that conquered the world.

Royal blue of the garter robes. Deep cobalt blue.

The great master of blue – the French painter Yves Klein. No other painter is commanded by blue, though Cézanne painted more blues than most.

BLUE IS BLUE.

Blue is hotter than yellow.

Blue is cold.
Icy blue.
Curaçao with ice.

The earth is blue.
The virgin's mantle is the bright blue sky.

This is the living blue.
The blue of Divinity.

Blue movies.
Blue language.
Bluebeard.

'Blue gives other colours their vibration', Cézanne. TRUE BLUE.

I am writing this wearing a Japanese workman's coat in tough linen of faded indigo. Indigo is the colour of clothes. Cobalt of glass. Ultramarine of painting. Indigo, Indekan from India, is found in woad and *Indigofera tinctoria*. Marco Polo noted the process of dyeing in Coulan.

Pull up the plants by the roots, put them in tubs of water till they rot. Press out the juice and evaporate it leaving a paste which is cut up into small pieces and sold.

The arrival of indigo in Europe caused consternation. Woad was under threat in 1577 in Germany. A decree prohibited 'the newly invented pernicious and deceitful, eating and corrosive dye called the Devil's Dye'. In France dyers were required to take oaths not to use indigo. For two centuries indigo was hedged with legislation.

Woad – Anglo Saxon: wad.
Weld yellow and woad blue.
Lincoln greens and welcoming blues.

The first artificial blue was Russian, discovered early in the eighteenth century.

Ficino writes in the Platonic Academy for Lorenzo:

We dedicate the sapphire to Jove

the Lapis Lazuli was given this colour
because its jovial power was against
Saturn's black bile.

It has a special place among colours.

Colour the little wall maps of the universe you are
making. The sapphire colour for the spheres of the
world. It would be useful not just to look at it, but to re-
flect on it in the soul. Deep inside your house you might
set up a little room and mark it with these figures and
colours.

(Ficino, op. cit.)

Asaao ya
Ichivin fukaki
Fuchi no ivo.

Ah! The blossoming
Morning glory
Deep pool of blue.

(Yosa Busoi)

For the Japanese, the morning glory is the English rose,
or Dutch tulip – deep blue, it blossoms at dawn and
fades in the sunlight.

The Japanese slept under blue mosquito nets to give the illu-
sion of peace and cool.

Something old,
Something new,
Something borrowed,
Something blue . . .

You say to the boy open your eyes
When he opens his eyes and sees the light

You make him cry out. Saying
O Blue come forth
O Blue arise
O Blue ascend
O Blue come in.

I am sitting with some friends in this café drinking coffee
served by young refugees from Bosnia. The war rages across
the newspapers and through the ruined streets of Sarajevo.

Tania said, 'Your clothes are on back to front and inside
out.' Since there were only two of us here I took them off
and put them right then and there. I am always here before
the doors open.

What need of so much news from abroad while all that con-
cerns either life or death is all transacting and at work within
me?

I step off the kerb and a cyclist nearly knocks me down. Fly-
ing in from the dark he nearly parted my hair.

I step into a blue funk.

The doctor in St Bartholomew's Hospital thought he could
detect lesions in my retina – the pupils dilated with bella-
donna – the torch shone into them with a terrible blinding
light.

Look left
Look down
Look up
Look right.

Blue flashes in my eyes.

Blue Bottle Buzzing
Lazy days

The sky blue butterfly
Sways on a cornflower
Lost in the warmth
Of the blue heat haze
Singing the blues
Quiet and slowly
Blue of my heart
Blue of my dreams
Slow blue love
Of delphinium days.

Blue is the universal love in which man bathes – it is the ter-
restrial paradise.

I'm walking along the beach in a howling gale –
Another year is passing
In the roaring waters
I hear the voices of dead friends
Love is life that lasts forever.
My heart's memory turns to you
David. Howard. Graham. Terry. Paul . . .

But what if this present
Were the world's last night?
In the setting sun you love fades
Dies in the moonlight
Fails to rise
Thrice denied by cock crow
In the dawn's first light.

Look left
Look down
Look up
Look right.
The camera flash
Atomic bright
Photos
The CMV – a green moon then the world turns magenta.

My retina
Is a distant planet
A red Mars
From a *Boy's Own* comic
With yellow infection
Bubbling at the corner.
I said this looks like a planet
The doctor says – 'Oh, I think
It looks like a pizza.'

The worst of the illness is the uncertainty.
I've played this scenario back and forth each hour of the day
for the last six years.

Blue transcends the solemn geography of human limits.

I am home with the blinds drawn
HB is back from Newcastle
But gone out – the washing
Machine is roaring away
And the fridge is defrosting
These are his favourite sounds.

I've been given the option of being an in-patient at the hospital or coming in twice a day to be hooked to a drip. My vision will never come back.

The retina is destroyed, though when the bleeding stops what is left of my sight might improve. I have to come to terms with sightlessness.

If I lose half my sight will my vision be halved?

The virus rages fierce. I have no friends now who are not dead or dying. Like a blue frost it caught them. At work, at the cinema, on marches and beaches. In churches on their knees, running, flying silent or shouting protest.

It started with sweats in the night and swollen glands. Then the black cancers spread across their faces – as they fought for breath TB and pneumonia hammered at the lungs, and Toxo at the brain. Reflexes scrambled – sweat poured through hair matted like lianas in the tropical forest. Voices slurred – and then were lost forever. My pen chased this story across the page tossed this way and that in the storm.

The blood of sensibility is blue.
I consecrate myself
To find its most perfect expression.

My sight failed a little more in the night.
HB offers me his blood.
It will kill everything he says.

The drip of DHPG
Trills like a canary.

I am accompanied by a shadow into which HB appears and disappears. I have lost the sight on the periphery of my right eye.

I hold out my hands before me and slowly part them. At a certain moment they disappear out of the corner of my eyes. This is how I used to see. Now if I repeat the motion, this is all I see.

I shall not win the battle against the virus – in spite of the slogans like 'Living with AIDS'. The virus was appropriated by the well – so we have to live with AIDS while they spread the quilt for the moths of Ithaca across the wine dark sea.

Awareness is heightened by this, but something else is lost. A sense of reality drowned in theatre.

Thinking blind, becoming blind.

In the hospital it is as quiet as a tomb. The nurse fights to
find a vein in my right arm. We give up after five attempts.
Would you faint if someone stuck a needle into your arm?
I've got used to it – but I still shut my eyes.

The Gautama Buddha instructs me to walk away from ill-
ness. But he wasn't attached to a drip.

Fate is the strongest
Fate Fated Fatal
I resign myself to Fate
Blind Fate
The drip stings
A lump swells up in my arm
Out comes the drip
An electric shock sparks up my arm.

How can I walk away with a drip attached to me?
How am I going to walk away from this?

I fill this room with the echo of many voices
Who passed time here
Voices unlocked from the blue of the long dried paint
The sun comes and floods this empty room
I call it my room
My room has welcomed many summers
Embraced laughter and tears
Can it fill itself with your laughter
Each word a sunbeam
Glancing in the light
This is the song of My Room.

Blue stretches, yawns and is awake.

There is a photo in the newspaper this morning of refugees
leaving Bosnia. They look out of time. Peasant women with
scarves and black dresses stepped from the pages of an older
Europe. One of them has lost her three children.

Lightning flickers through the hospital window – at the door an elderly woman stands waiting for the rain to clear. I ask her if I can give her a lift, I've hailed a taxi. 'Can you take me to Holborn tube?' On the way she breaks down in tears. She has come from Edinburgh. Her son is in the ward – he has meningitis and has lost the use of his legs – I'm helpless as the tears flow. I can't see her. Just the sound of her sobbing.

One can know the whole world
Without stirring abroad
Without looking out of the window
One can see the way of heaven
The further one goes
The less one knows.

In the pandemonium of image
I present you with the universal Blue
Blue an open door to soul
An infinite possibility
Becoming tangible.

Here I am again in the waiting room. Hell on Earth is a waiting room. Here you know you are not in control of yourself, waiting for your name to be called: '712213'. Here you have no name, confidentiality is nameless. Where is 666? Am I sitting opposite him/her? Maybe 666 is the demented woman switching the channels on the TV.

What do I see
Past the gates of conscience
Activists invading Sunday Mass
In the cathedral
An epic Czar Ivan denouncing the
Patriarch of Moscow
A moon-faced boy who spits and repeatedly
Crosses himself – as he genuflects
Will the pearly gates slam shut in

112

The faces of the devout.

The demented woman is discussing needles – there is always a discussion of needles here. She has a line put into her neck.

How are we perceived, if we are to be perceived at all? For the most part we are invisible.

If the Doors of Perception were cleansed then everything would be seen as it is.

The dog barks, the caravan passes.

Marco Polo stumbles across the Blue Mountain.

Marco Polo stops and sits on a lapis throne by the River Oxus while he is ministered to by the descendants of Alexander the Great. The caravan approaches, blue canvasses fluttering in the wind. Blue people from over the seas – ultramarine – have come to collect the lapis with its flecks of gold.

The road to the city of Aqua Vitae is protected by a labyrinth built from crystals and mirrors which in the sunlight cause terrible blindness. The mirrors reflect each of your betrayals, magnify them and drive you into madness.

Blue walks into the labyrinth. Absolute silence is demanded of all its visitors, so their presence does not disturb the poets who are directing the excavations. Digging can only proceed on the calmest of days as rain and wind destroy the finds.

The archaeology of sound has only just been perfected and the systematic cataloguing of words has until recently been undertaken in a haphazard way. Blue watched as a word or phrase materialised in scintillating sparks, a poetry of fire which cast everything into darkness with the brightness of its reflections.

As a teenager I used to work for the Royal National Institute for the Blind on their Christmas appeal for radios, with dear Miss Punch, seventy years old, who used to arrive each morning on her Harley Davidson.

She kept us on our toes. Her job as a gardener gave her time to spare in January. Miss Punch Leather Woman was the first out dyke I ever met. Closeted and frightened by my sexuality she was my hope. 'Climb on, let's go for a ride.' She looked like Edith Piaf, a sparrow, and wore a cock-eyed beret at a saucy angle. She bossed all the other old girls who came back year after year for her company.

In the paper today. Three quarters of the AIDS organisations are not providing safer sex information. One district said they had no queers in their community, but you might try district X – they have a theatre.

My sight seems to have closed in. The hospital is even quieter this morning. Hushed. I have a sinking feeling in my stomach. I feel defeated. My mind bright as a button but my body falling apart – a naked light bulb in a dark and ruined room. There is death in the air here but we're not talking about it. But I know the silence might be broken by distraught visitors screaming, 'Help Sister! Help Nurse!' followed by the sound of feet rushing along the corridor. Then silence.

Blue protects white from innocence
Blue drags black with it
Blue is darkness made visible

Over the mountains is the shrine to Rita, where all at the end of the line call. Rita is the Saint of the Lost Cause. The saint of all who are at their wits' end, who are hedged in and trapped by the facts of the world. These facts, detached from cause, trapped the Blue Eyed Boy in a system of unreality. Would all these blurred facts that deceive dissolve in his last breath? For accustomed to believing in image, an absolute

idea of value, his world had forgotten the command of essence: Thou Shall Not Create Unto Thyself Any Graven Image, although you know the task is to fill the empty page. From the bottom of your heart, pray to be released from image.

Time is what keeps the light from reaching us.

The image is a prison of the soul, your heredity, your education, your vices and aspirations, your qualities, your psychological world.

I have walked behind the sky.

For what are you seeking?

The fathomless blue of Bliss.

To be an astronaut of the void, leave the comfortable house that imprisons you with reassurance. Remember, to be going and to have are not eternal – fight the fear that engenders the beginning, the middle and the end.

For Blue there are no boundaries or solutions.

How did my friends cross the cobalt river, with what did they pay the ferryman? As they set out for the indigo shore under this jet-black sky – some died on their feet with a backward glance. Did they see Death with the hell hounds pulling a dark chariot, bruised blue-black, growing dark in the absence of light, did they hear the blast of trumpets?

David ran home panicked on the train from Waterloo, brought back exhausted and unconscious to die that night. Terry who mumbled incoherently into his incontinent tears. Others faded like flowers cut by the scythe of the Blue Bearded Reaper, parched as the waters of life receded. Howard turned slowly to stone, petrified day by day, his

mind imprisoned in a concrete fortress until all we could hear were his groans on the telephone circling the globe.

We all contemplated suicide
We hoped for euthanasia
We were lulled into believing
Morphine dispelled pain
Rather than making it tangible
Like a mad Disney cartoon
Transforming itself into
Every conceivable nightmare.

Karl killed himself – how did he do it? I never asked. It seemed incidental. What did it matter if he swigged prussic acid or shot himself in the eye? Maybe he dived into the streets from high up in the cloud-lapped skyscrapers.

The nurse explains the implant. You mix the drugs and drip yourself once a day. The drugs are kept in a small fridge they give you.

Can you imagine travelling around with that? The metal implant will set the bomb detector off in airports, and I can just see myself travelling to Berlin with a fridge under my arm.

Impatient youths of the sun
Burning with many colours
Flick combs through hair
In bathroom mirrors
Fucking with fusion and fashion
Dance in the beams of emerald lasers
Mating on suburban duvets
Cum splattered nuclear breeders
What a time that was.

The drip ticks out the seconds, the source of a stream along which the minutes flow, to join the river of hours, the sea of years and the timeless ocean.

The side effects of DHPG, the drug for which I have to come into hospital to be dripped twice a day, are: low white blood cell count, increased risk of infection, low platelet count which may increase the risk of bleeding, low red blood cell count (anaemia), fever, rash, abnormal liver function, chills, swelling of the body (oedema), infections, malaise, irregular heart beat, high blood pressure (hypertension), low blood pressure (hypotension), abnormal thoughts or dreams, loss of balance (ataxia), coma, confusion, dizziness, headache, nervousness, damage to nerves (paraesthesia), psychosis, sleepiness (somnolence), shaking, nausea, vomiting, loss of appetite (anorexia), diarrhoea, bleeding from the stomach or intestine (intestinal haemorrhage), abdominal pain, increased number of one type of white blood cell, low blood sugar, shortness of breath, hair loss (alopecia), itching (pruritus), hives, blood in the urine, abnormal kidney function, increased blood urea, redness (inflammation), pain or irritation (phlebitis).

Retinal detachments have been observed in patients both before and after initiation of therapy. The drug has caused decreased sperm production in animals and may cause infertility in humans, and birth defects in animals. Although there is no information in human studies, it should be considered a potential carcinogen since it causes tumours in animals.

If you are concerned about any of the above side effects or if you would like any further information, please ask your doctor.

In order to be put on the drug you have to sign a piece of paper stating you understand that all these illnesses are a possibility.

I really can't see what I am to do. I am going to sign it.

The darkness comes in with the tide

The year slips on the calendar
Your kiss flares
A match struck in the night
Flares and dies
My slumber broken
Kiss me again
Kiss me
Kiss me again
And again
Never enough
Greedy lips
Speedwell eyes
Blue skies.

A man sits in a wheelchair, his hair awry, munching through a packet of dried biscuits, slow and deliberate as a praying mantis. He speaks enthusiastically but sometimes incoherently of the hospice. He says, 'You can't be too careful who you mix with there, there's no way of telling the visitors, patients or staff apart. The staff have nothing to identify them except they are all into leather. The place is like an S&M club.' This hospice has been built by charity, the names of the donors displayed for all to see.

Charity has allowed the uncaring to appear to care and is terrible for those dependant on it. It has become big business as the government shirks its responsibilities in these uncaring times. We go along with this, so the rich and powerful who fucked us over once fuck us over again and get it both ways. We have always been mistreated, so if anyone gives us the slightest sympathy we overreact with our thanks.

I am a mannish
Muff diving
Size queen
With bad attitude
An arse licking
Psychofag

Molesting the flies of privacy
Balling lesbian boys
A perverted heterodemon
Crossing purpose with death.

I am a cock sucking
Straight acting
Lesbian man
With ball crushing bad manners
Laddish nymphomaniac politics
Spunky sexist desires
Of incestuous inversion and
Incorrect terminology
I am a Not Gay.

HB is in the kitchen
Greasing his hair
He guards the space
Against me
He calls it his office
At nine we leave for the hospital.

HB comes back from the eye dept
Where all my notes are muddled
He says
It's like Romania in there
Two light bulbs
Grimly illuminate
The flaking walls
There is a box of dolls
In a corner
Indescribably grimy
The doctor says
Well of course
The kids don't see them
There are no resources
To brighten the place up.

My eyes sting from the drops
The infection has halted
The flash leaves
Scarlet after-images
Of the blood vessels in my eye.

Teeth chattering February
Cold as death
Pushes at the bedsheets
An aching cold
Interminable as marble
My mind
Frosted with drugs ices up
A drift of empty snowflakes
Whiting out memory
Cross-eyed meddlesome consciousness
A blinkered twister
Circling in spirals
Shall I? Will I?
Doodling death watch
Mind how you go.

Oral DHPG is consumed by the liver, so they have tweaked
a molecule to fool the system. What risk is there? If I had to
live forty years blind, I might think twice. Treat my illness
like the dodgems: music, bright lights, bumps and throw
yourself into life again.

The pills are the most difficult, some taste bitter, others are
too large. I'm taking about thirty a day, a walking chemical
laboratory. I gag on them as I swallow them and they come
up half dissolved in the coughing and spluttering.

My skin sits on me like the shirt of Nessus. My face irritates,
as do my back and legs at night. I toss and turn, scratching,
unable to sleep. I get up, turn on the light. Stagger to the
bathroom. If I become so tired, maybe I'll sleep. Films chase

through my mind. Once in a while I dream a dream as magnificent as the Taj Mahal. I cross Southern India with a young spirit guide – India the land of my dreaming childhood. The souvenirs in Moselle's peach and grey living room. Granny, called Moselle, called 'Girly', called May. An orphan who lost her name, which was Ruben. Jade monkeys, ivory miniatures, Mah-Jong. The winds and bamboos of China.

All the old taboos of
Blood lines and blood banks
Blue blood and bad blood
Our blood and your blood
I sit here – you sit there.

As I slept a jet slammed into a tower block. The jet was almost empty but two hundred people were fried in their sleep.

The earth is dying and we do not notice it.

A young man frail as Belsen
Walks slowly down the corridor
His pale green hospital pyjamas
Hanging off him
It's very quiet
Just the distant coughing
My jugsy eye blots out the
Young man who has walked past
My field of vision
This illness knocks you for six
Just as you start to forget it
A bullet in the back of the head
Might be easier
You know, you can take longer than
The Second World War to get to the grave.

Ages and Aeons quit the room

Exploding into timelessness
No entrances or exits now
No need for obituaries or final judgments
We knew that time would end
After tomorrow at sunrise
We scrubbed the floors
And did the washing up
It would not catch us unawares.

The white flashes you are experiencing in your eyes are common when the retina is damaged.

The damaged retina has started to peel away leaving innumerable black floaters, like a flock of starlings swirling around in the twilight.

I am back at St Mary's to have my eyes looked at by the specialist. The place is the same, but there is new staff. How relieved I am not to have the operation this morning to have a tap put in my chest. I must try to cheer up HB as he has had a hell of a fortnight. In the waiting room a little grey man over the way is fretting as he has to get to Sussex. He says, 'I am going blind, I cannot read any longer.' A little later he picks up a newspaper, struggles with it for a moment and throws it back on the table. My stinging eye drops have stopped me reading, so I write this in a haze of belladonna. The little grey man's face has fallen into tragedy. He looks like Jean Cocteau without the poet's refined arrogance. The room is full of men and women squinting into the dark in different states of illness. Some barely able to walk, distress and anger on every face and then a terrible resignation.

Jean Cocteau takes off his glasses, he looks about him with an undescribable meanness. He has black slip-on shoes, blue socks, grey trousers, a Fairisle sweater and a herringbone jacket. The posters that plaster the walls above him have endless question marks, HIV/AIDS?, AIDS?, HIV?, ARE YOU AFFECTED BY HIV/AIDS?, AIDS?, ARC?, HIV?

This is a hard wait. The shattering bright light of the eye specialist's camera leaves the empty sky-blue after-image. Did I really see green the first time? The after-image dissolves in a second. As the photographs progress, colours change to pink and the light turns to orange. The process is a torture, but the result, stable eyesight, worth the price and the twelve pills I have to take a day. Sometimes looking at them I feel nauseous and want to skip them. It must be my association with HB, lover of the computer and king of the keyboard that brought my luck on the computer which chose my name for this drug trial. I nearly forgot as I left St Mary's I smiled at Jean Cocteau. He gave a sweet smile back.

I caught myself looking at shoes in a shop window. I thought of going in and buying a pair, but stopped myself. The shoes I am wearing at the moment should be sufficient to walk me out of life.

Pearl fishers
In azure seas
Deep waters
Washing the isle of the dead
In coral harbours
Amphora
 Spill
 Gold
Across the still seabed
We lie there
Fanned by the billowing
Sails of forgotten ships
Tossed by the mournful winds
Of the deep
Lost boys
Sleep forever
In a deep embrace
Salt lips touching
In submarine gardens
Cool marble fingers

Touch an antique smile
Shell sounds
Whisper
Deep love drifting on the tide forever
The smell of him
Dead good looking
In beauty's summer
His blue jeans
Around his ankles
Bliss in my ghostly eye
Kiss me
On the lips
On the eyes
Our name will be forgotten
In time
No one will remember our work
Our life will pass like the traces of a cloud
And be scattered like
Mist that is chased by the
Rays of the sun
For our time is the passing of a shadow
And our lives will run like
Sparks through the stubble.

I place a delphinium, Blue, upon your grave.

Isaac Newton

Nature and Nature's laws lay hid in night,
God said, *Let Newton be!* and all was light.

Isaac born into a yeoman's family in the Lincolnshire
countryside in 1642. Was admitted to Trinity on the 5th
June 1661. In August 1665 Sir Isaac, then not 24, bought
a prism in Stourbridge Fair to try some experiments on
Descartes' Book of Colours and when he had come
home he made a hole in his shutter and darkened the
room and put his prism between that and the wall found
instead of the circle of light, it made a spectrum with
straight sides and circular ends and which convinced
him immediately that Descartes was wrong. He then
found out by his own hypothesis of colours that he
could not demonstrate it for want of another prism for
which he stayed for the next Stourbridge Fair and then
proved what he had before found out.

(John Conduit)

White light shattered into colour, Isaac in his closet, married
to his prism and gravity with a little alchemy on the side. A
glance over the shoulder made the step, as Pope said, into
the light, a light that he saw as multitudes of unimaginably
small and swift corpuscles of various sizes springing from
shining bodies at great distances one after another, but yet
without any sensible interval of time.

He noted:

The most refracted rays produce purple colours and those
least refracted red, while those that proceed along inter-
mediate lines generate the intermediate colours, blue, green
and yellow.

There are seven colours, the perfect number, one for every day of the week, and Sunday is violet.

It appears also that white is a dissimilar mixture of all the colours and the natural light is a mixture of rays endowed with all these colours.

Newton became a God like Jupiter and Mars for the philosophers like Voltaire.

Purple Passage

Rose red city
Half as old as time.

Pink, mauve and violet jostle each other from red to black.

Roses are red
Violets are blue.

Poor violet violated for a rhyme.

There is no natural pink pigment, though you can buy something called 'flesh tint' which in no way resembles the pasty faces of the north or the tanned ones of the south.

Mauve is a chimera. It barely exists except as a description of the 1890s, the Mauve Decade.

Purple marches and violet shrinks.

Pink begat mauve begat purple begat violet . . .

. . . with the exception of violet they are allies. Violet is respectable.

The rarest and most beautiful eyes are violet. I'm told that is the secret of Elizabeth Taylor.

Pink is always shocking. Naked. All those acres of flesh that cover the ceilings of the Renaissance. Pontormo is the pinkest painter.

Purple is passionate, maybe violet becomes a little bolder and FUCKS pink into purple. Sweet lavender blushes and watches.

THINK PINK!

Pink was the passion of the Mauve Decade – the Ballets
Roses that Baron Fersen staged with young children for rich
matrons at tea. Were these naked children innocent? The
baron caused a scandal with other youthful indiscretions and
support was withdrawn from him by the wealthy ladies, who
sat admiring the children, posed as Venus and Adonis, Her-
cules and any number of Graces. Fersen left Paris in a hurry
for the south, where he built a villa in Capri. Mauve had
found its home. Fersen's taste was not for children, so there
was no paedophilia in the pink. He was after young navvies,
and picked one up – a surprisingly handsome straight boy
who lived with him faithfully to the end, polishing and filling
the baron's jade opium pipes.

Opium is the mauve drug. It brings to mind this time with its
mysterious acrid smell.

You will find that Christ's robe in many medieval paintings,
Piero della Francesca's *Resurrection*, for instance, is bright
pink.

In the 1950s the song 'Think Pink' restored the colour to
popularity. The Fifties were a pink decade. There is pink in
the make-up of sex-goddesses. Marilyn Monroe was cer-
tainly pink. Those Venuses who wore nothing but coral
beads – peek-a-boo pink.

The pink nubile ladies of the music hall in flesh-coloured
tights.

Valentino tinted pink in the movies.

'In the Pink'. My dictionary says: 'in the most perfect
health', though Venus gave her name to shady diseases and
haunted the clap clinic.

Pink eyed.

She was dressed by Schiaparelli in shocking pink. Lipstick pink. Pink icing. Soap and the packaging of cosmetics was pink. Pink flattered. In that world big girls as well as little girls wore pink.

Against this earthly pink, Rudolf Steiner proposed peach blossom, representing the living image of the soul as revealed in the colour of the human skin. Colour becomes a nonsense – I wonder if Steiner had been black he would have swapped the colours? Only when a soul withdraws, he says, does a person turn green. This again is nothing to do with the soul, the muddle that Ludwig Wittgenstein perceived in the use of that word, the soul as concrete, is clear here. The green is just a physiological state brought in by the withdrawal of blood from the epidermis. Souls do not have colour.

At twenty I painted pictures in pink. Pink interiors with pink girls. Was this a burgeoning of my sexuality?

Twenty years later. The pink triangle was reclaimed from history. The Nazis used pink to send those in same-sex relationships to the gas chamber.

When Queen Mary visited my father's RAF station at Kidlington early in the Fifties, a pink lavatory was built for her visit. The entire station trooped past it, no one had ever seen anything like it. In the event she never used it.
Later pink bathrooms became the rage. You'll grow a little lovelier each day with wonderful pink Camay.

This afternoon I walked to Rowneys and bought a tube of Flesh Tint.

Pink is the navy blue of India.

(Diana Vreeland)

And so to mauve . . .

MAUVE

Mowve, pronounced Morv by the late Victorians, became a rage in fashion after the aniline dye was produced from coal. It was discovered in 1856 by William Perkins, who mixed aniline and chromic acid. It seems to have had little time to gather much mystery – where does it appear in poetry? It is confined to the chemistry lesson.

Its use for cloth dyeing led to the naming of the Mauve Decade. It was identified with decadence and artificiality. The black of mourning was touched with violet not mauve. No Victorian matron dressed in mauve.

I stopped at Elizabeth Stranger's Hellebore Heaven this morning and bought a plant from her greenhouse with a mass of mauve flowers.

PURPLE

Imperial purple marching out of antiquity. Priceless Tyrian purple.

My mother used to say in her youth if one had tresses bound in purple that was a great adornment – but for the girl whose hair is yellower than a torch it is better to dress in chaplets of blooming flowers.

(Sappho, *Greek Lyrical Poetry*)

Purple is gay and bright whenever the rays of the sun are weak and shady.

(Aristotle, op. cit.)

Purple shrouds the blackest heart. The imperial family wrapped their newborn children in purple – born in the purple.

Desdemona's handkerchief was purple in Verdi's *Otello*.

On purple sheets I see cheap flatterers sprawl drunkenly.

(Petronius)

Cleopatra's barge . . .
Burn'd on the water; the poop was beaten gold,
Purple the sails, and so perfumed that
The winds were love-sick with them.

Lady Grey, megalomaniac, Vicereine of India, had an obsession for imperial purple. Not only did she wear it, but she had purple tablecloths at her reception, purple sweet wrappers, and even purple flowers.

In Japan if you're purple you're purple with envy, not green. But purple is also an expression for being gay, the blue of men and the red of women combine to make queer purple.

The lack of oxygen turns me purple. I lie in my hospital bed, short of breath.

Purple is verbose, the purple passage. Angry, purple passion overblown. Purple in the face.

Nero dressed in purple, the household in red.

If anger is red then rage is purple.

As Nero torched Rome his face turned purple.

Purple was manufactured on the shores of the Sea of Tyre

... Tyrian purple. It was extracted in minute quantities from a shell, *Murex*, and cloth was boiled with dye and exposed to the morning sun on the seashore, turning it into the most costly product in antiquity. Its manufacture was controlled by the Imperial Family in the Collegium Tinctorium under the auspices of Melcath the Phoenician God. As no example of purple cloth remains from antiquity, we do not know what it looked like.

Was it the colour of the Scottish highland, beyond the known world, or the inky flowers of the anemone – the flower of the wind? The *Murex*, a mollusc, contained a little cyst that was broken – discharging a white fluid. Thousands of shells were needed for a few grams. By the eighth century the colour went out of fashion.

Purple in painting was disapproved of by Pliny, who remarked acidly:

> Now that purple is put to use on our walls and India contributes with the mud of the rivers and with the gore of her snakes and elephants, there is no longer noble painting . . . now we only appreciate the richness of the material.

> (Jacob Isagev, *Pliny in Art*)

We are suspicious of purple, it has a hollow bombast. It is the colour of Hendrix, Purple Haze, Deep Purple. Prince's excess – dangerous. The purple hearts that took us through the sober nights of the Sixties.

> O, for a draught of vintage! that hath been
> Cool'd a long age in the deep-delved earth,
> Tasting of Flora and the country green,
> Dance and Provencal song, and sunburnt mirth!

O for a beaker full of the warm South,
Full of the true, the blushful Hippocrene
With beaded bubbles winking at the brim,
And purple stained mouth . . .

(John Keats, *Ode to a Nightingale*)

Aristotle:

The sea has a purple tinge when
The waves rise at an angle
And are consequently in shadow.

The purple emperor embraces the purple orchid. The emperor is rare, it is attracted to rotting meat.

Plums, grapes and figs and aubergine all purple – but the most mysterious purple are the shoots of *Crambe maritima* which push through the shingle in March at Dungeness, before forming a blue green.

The red cabbage is purple.

The purple amethyst, my birth stone – 31 January, under the sign of Aquarius.

SHRINKING VIOLET

Who walked between the violet and the violet
Who walked between
The various ranks of varied green
Going in white and blue, in Mary's colour,
Talking of trivial things . . .

(T S Eliot, *Ash-Wednesday*)

Violet is overwhelmed by green. The Violet hides itself. Sweet-scented *Viola odorata*.

The only colour in the spectrum named after a flower. The humble violet flower. The flower of Mary Magdalene. Worn in mourning by my grandmother May. Bunches of violets from Cornwall heralded the spring. My aunt Violet . . . Vi . . . an Edwardian spinster who lived with her sister guarding the legacy of a tyrannical father who never let a suitor cross the doorstep. Quick-tongued and salty.

It was said Alexander the Great's urine smelled of violets.

Humble intuitive violet
Gathering the shadows.

Crystallised Parma violets, a childhood treat
I have not seen for years
And gentian violet to cleanse cuts from the football pitch.

'Athens,' wrote Pindar, 'is violet crowned.'

Violet chaplets were sold in the markets. Pliny had a terrace scented with violets.

Violet has the shortest wavelength of the spectrum. Behind it the invisible ultraviolet.

As a nine-year-old on the cliffs at Hordle I discovered a bank of sweet violets and used to creep through the hedge that enclosed the school playing field and lie in the sun dreaming. What did I dream in my violet youth?

Jupiter was violet and not imperial purple.

Violet paint is rarely used. Where do you see it on a canvas? The Impressionists created violet shadows in the Mauve Decade. Monet's haystacks awash with pinks and violets in the sunset.

Of all the colours violet is a luxury. Cobalt violet – manganese violet – ultramarine violet – and Mars violet.

Kandinsky said: 'Violet is red withdrawn from humanity by blue.'

But the red in violet must be cold Violet is therefore both in the physical and spiritual sense a cooled red. It is sad and ailing.

Christian violet, a temporary death to the world.

Adriana Lecouvreur was killed by a jealous lover with a bunch of poisoned violets.

Black Arts
O Mia Anima Nera

Oh, my black soul, 'Now thou art summoned by sicknesse', death's herald and champion.

Black velvet registers as infinity on film with no form or boundary, a black without end, that lurks behind the blue sky. It is soulful, and as Ad Reinhardt's *The Quintessential Master of Black* stated ... it does away with petty incident and the romance of the coloured surface. It is puritan, black as the clothes of the seventeenth-century burghers of Amsterdam.

A priestly black. Black hearted.

Victorian ladies mourning in jet.

Beyond the galaxies lies that primordial dark from which the stars shine out. There are green stars and red giants. Betelgeuse is a red star, and there are blue stars like Rigel. Their colours tell us much: hydrogen is red, sodium is orange.

You set the colours against each other and they sing. Not as a choir but as soloists. What is the colour of the music of the spheres but the echo of the Big Bang on the spectrum, repeating itself like a round?

Today, as I write this, the Hubble telescope is photographing the very edge of the universe. The beginning of time. Worlds whose light has taken longer to get there than the existence of the Earth itself. Lurking black holes where time, space and dimension cease to exist.

Will my voice echo till time ends? Will it journey forever into the void?

Is black hopeless? Doesn't every dark thundercloud have a silver lining? In black lies the possibility of hope.

The universal sleep is hugged by black. A comfortable, warm black. This is no cold black, it is against this black that the rainbow shines like the stars. This is beautifully put by Ovid in the *Metamorphoses*:

> Iris put on her robe of a thousand colours and tracing a curved arc across the heavens sought the cloud wrapped palace of the King. Near the Cimmerian country is a cave, deeply recessed, a hollow mountainside, the secret dwelling place for languid sleep, where the sun's rays can never reach. Whether at his rising, or at noon, or at his setting. Dark mists are breathed out from the ground, and the half-light of evening's gloom. No crested cock summons the dawn with wakeful crowings, no anxious dogs break the silence, or geese, shrewder still than dogs. No wild beasts are heard, no cattle, nor is there any sound of branches swaying in the wind, or harsh quarrelling of human tongues. Voiceless quiet dwells there: but from the depths of the rocky cave flows the river of Lethe, whose waters invite slumber as they glide, murmuring over whispering pebbles. Before the door the house poppies bloom in abundance and countless herbs from whose juices dewy Night gathers drowsiness and sprinkles it over the dark earth. There is not a door in the whole house, lest some hinge should creak, nor is there any watchman at the threshold. In the midst of the cavern stands a lofty couch of ebon wood, dark in colour, covered with black draperies, feather soft, where the god himself lies, his limbs relaxed in luxurious weariness. Around him lie empty dreams, made to resemble different shapes, as many as the corn ears in the

harvest, as leaves on the woodland trees, or sands scattered on the shore.

It never rained in the House of Sleep. Did Iris light her way in the darkness? Did Morpheus dream of the rainbow at his bedside?

Black is boundless, the imagination races in the dark. Vivid dreams careering through the night. Goya's bats with goblin faces chuckle in the dark.

In the black coal fire lives the spirit of storytelling. Flickering blue and scarlet flames. It was around the fire at night that men and women told their stories in the pitchy black.

Black Sabbaths.

The fire burnt out, the hearth was boarded up, the television arrived. The electronic media stole the narrative, leaving us with the endless repetition talked at rather than talking. Black is not their song, it is yours.

The little sweep might bring good luck, black-faced at a white wedding, but he was tortured. His elbows and knees grazed and hardened into callous tissue with vinegar. He died young. His lungs cancerous with soot. The chimneys of Buckingham Palace were the most dreaded, an evil house whose flues formed a hairpin 'N' – up, down and up again before he came to the light. Luck came at a price for the climbing boys. What did the world of gentlemen in black top hats and black umbrellas care for them?

There is luck and bad luck in black. Jet, the tame crow that came each morning to Prospect Cottage and stole everything that glittered . . . red sweets, blue wool, silver paper, and buried them in secret hideaways at the end of the garden. Thomas the old black cat plods along, stalking his dinner

through the broom, blackened by salt spray. My crow followed me for miles when I went blackberrying, swooping low over my head, making me duck.

There is forbidden black.

The black monk who gabbles black magic as he conducts a black mass. Black death enters the room, the candlelight extinguished in a last breath. The acid smell of the wreath of smoke in the despairing dawn.

Black as a funeral, sooty lamp black lights the way . . .

The lamp blacks of funerals. This one on a jerky film is of the Emperor Franz Josef. Black hearse. Black horses. Black ostrich plumes. The soldiers and imperial household in black mourning. Crape and armband. Jet necklaces, black veils. The old order passes and is gone, sent on its way by priests who have thrown off their black everyday for gold and pomp.

Black is beautiful.

Muhammad Ali floats like a butterfly . . . stings like a bee.

Behind the green centre of the Moslem world lies the black stone – the Ka'abo.

The world is as black as ink. Books are printed in black.

Days, grinding etching ink at the Slade, sticky as treacle on the stone. The etchings took less time than the ink.

There is a black which is old and a black which is fresh.

(Hokusai)

Melanosis, moths which turn black to hide from predators.

Black beetles. Black panthers stalking black sheep. Black swans and ravens.

The black flowers are viola, black as velvet. Black tulips tinged with purple, and black hellebores that bloom in winter. There are white gardens but no black gardens.

Black could be humorous. Could be modern. Coco Chanel's little black dress for all occasions.

But black was also the Inquisition.

The evil black shirts were marching in the East End, fighting the blue police, as she danced the Black Bottom.

While in the pub, the black leather boys pull their insecurity and beer bellies into form – aspiring to be Marlon Brando.

'Is their underwear black?'

Sexy Soho black?

Do they lie on black sheets?

Black taxis. Black telephones. Black Maria. Practical black. Dissolves form. Ivory black. The charcoal formed by heating ivory shavings and bones. Is there not contradiction?

Burning the white brings us black, but as Ad Reinhardt says:

> Matte black in art is
> not matte black
> Gloss black in art is gloss black
> Black is not absolute
> There are many different blacks
> Does the absence of light bring nothingness?
> steal its blacks.

Black is not exhibited in so elementary a state as white. We meet with it in the vegetable kingdom in semi conbustion and charcoal ... Various metals become black by slight oxidation.

<div style="text-align: right">(Goethe, op. cit.)</div>

Black Boards
Black Beauty
Black Mountains
Black Forest
Black Country
Black Seas
Blackpool
Charcoal Sticks
Carbon Arcs
Bone Black
Lamp Black.

I painted the gold into my black paintings (melanosis), the philosophic egg. The scarlet fire of the furnace, not as reproduction. This was the Quest, not a parody – the Quest that could end with a burning in the Field of Flowers – like Bruno who described the Universe as numerous worlds sparkling like dust in a shaft of sunlight. You could get more than your fingers burnt for that thought.

Silver and Gold

What is it that separates silver and gold from the colours? Is gold, for instance, yellow? Is silver, for instance, grey? Is it because they are metals? Is it because of their lustre or their value?

Midas and Croesus, take a bow.

Silver and gold have I none, but I do have golden oldies, golden moments and silence. Gold is not a colour, but it nestles up to the colours and shows them off.

Sovereigns and standards.

Gold discs for golden lads and lasses, who unlike the incorruptible metal must come to dust.

The smile of Tutankhamun
Oak leaved crowns
Cloth of gold
Adventure and Romance
Galleons
Inca gold

Pagodas, Russian churches, gold leaf.

Cornish gold, red gold, green gold, gold at the end of the rainbow.

The most golden painting – just a little blue lapis on the virgin's robe – is Simone Martini's *Annunciation*. Gold medieval paintings. Yves Klein throwing gold bars into the Seine. Torcello, where black demons writhe in the gold mosaic, taking the damned to hell.

Gold steals souls in Siberia. Gold rushes in the Yukon.

The pen with which I write this is a solid gold Waterman from 1905, a joy to pick up with a fine nib and flow.

Gold bonds in wedding rings.

There is no substitute for gold, it cannot be invented in the chemist's shop like the colours. Venus' golden apple, gold armour. Lady Docker's gold Daimler.

> Gold is a child of god.
> No moth or worm eats it,
> and it overcomes mortal
> beings – even the strongest.
>
> (Sappho, op. cit.)

Poor sad silver corrupts. Butlers polish the services of the rich. The black oxides stain the cloth. I have a silver razor which I bought on my first *Caravaggio* trip to Rome that I have treasured ever since. I don't have silver knives or forks. By the tone of this you can see silver is within our reach. Silver is useful. I can't think of a painting. It's far away from the spectrum. Silver leaf. Silver weddings. The silvery moon. Silver is for the night. Silvery seas, silver fishes flashing through seas, quicksilver, the goldfish ambles its way round the fountain. Silver fox, silver osprey, silver gilt, silver threepenny bits in the pudding. Silver brings luck.

Iridescence

Who has not gazed in wonder at the snaky shimmer of petrol patterns on a puddle, thrown a stone into them and watched the colours emerge out of the ripples, or marvelled at the bright rainbow arcing momentarily in a burst of sunlight against the dark storm clouds?

The rainbow that was the covenant to Noah after the great deluge.

The strutting peacock with its acid cry, opening its tail. Shot silver and velvet, changing colour before our eyes.

The iridescent opal and moonstone, cool and mysterious, and the mother of pearl shell. Lustrous with colours, we all blew soap bubbles with rainbows into a sunny sky, which burst and disappeared as they sailed away.

Iridescence brings back childhood, shifting like a kaleidoscope.

The sad eyed chameleon
volcano grey
sits on his rock
on a thundery day
grey is his coat
and grey is his heart
grey-eyed chameleon
in deep grey thought.

A rainbow appeared
in a sudden squall
and big fat rain drops
started to fall.

'Oh rainbow colour
please wash away
the grey in my life
the grey of the day.'

Squall heard this wish
and there and then
blew him away
to the rainbow's end
where on the ground
lay a lustrous shell
rainbow bright
Mother of Pearl.
Opaline pearl
moonstone bright
petrol on puddles
and shimmering bubbles
Mother of Pearl is my delight.

Translucence

Sabrina fair,
Listen where thou art sitting
Under the glassy, cool, translucent wave,
In twisted braids of lilies knitting
The loose train of thy amber-dropping hair;
Listen for dead honour's sake,
Goddess of the silver lake,
Listen and save.

Listen and appear to us
In name of great Oceanus,
By the earth-shaking Neptune's mace . . .

(John Milton, *Comus; a Masque Presented at Ludlow Castle*)

'I left off my glasse works for I saw that perfection of refracting telescopes was hitherto limited. Not so much that want of glasses, truly figured according to the prescriptions of optic authors, which all men have hitherto imagined but because the light itself is a heterogeneous mix of differently refrangible rays.'

(Isaac Newton op. cit.)

Time slips through the hour glass, measured with sand.

'To see the world in a grain of sand'.

Sand and soda or potash the recipe of glass.

The glass globe with its scarlet snowstorm, smashed in my hands, dyeing the sheets red. Glass is the key to the exploration of our world. It was through glass that Galileo explored the solar system; it was a glass prism that gave Newton the spectrum. As the manufacture of glass in the

seventeenth century advanced so did discovery. Grinding of lenses. Magnifying glass. Glass spectacles. Lustrous, hard and brittle.

> A man who looks on glass,
> On it may stay his eye;
> Or if he pleaseth, through it pass,
> And then the heaven espy.
>
> (George Herbert, *The Elixir*)

It was through an 'absence' of colour – colourlessness – that we measured the stars, created the spectrum. Then came microscopes to reveal the invisible within.

Painters walked hand in hand with scientists. They recorded the world in the camera obscura. Is that the secret of Vermeer? The world was fixed in silver on glass negatives. Glass is as vital as oxygen. The Hubble telescope has a lens ground to an accuracy that Galileo could never have imagined. Glass is the salt of intellect – a seeing through, its transparency pushes into dark corners.

There is a small silver box in the British Museum's medieval section – its top covered with seed pearls, magnified by a crystal lens. I go to see this box with a sense of wonder.

In 1972 I slept in a glass house in the warehouse at Bankside – a crystal paradise easily heated in the freezing winter, a practical solution.

Where did glass appear in my films?

Faces distorted, pressed to the window. Mad in *Jubilee*, and Ariel in *The Tempest*. Is there more toil.

The etched panes of diamond glass in *Angelic Conversation*. Glasses and blue chalk.

TRANSLUCENCE

The prisms in the centre of the *Shadow of the Sun* and *Art of Mirrors*. In Wittgenstein, Mr Green, the Quark of Charm and Strangeness, flashes a halo of light back into the camera. Light obliterates the image.

Many years ago I had tea with Philip Johnson in his glass house. Glass was modern. It is on glass that the timeless music of the spheres is created.

A phosphorescent apparition
Translucent in my ghostly eye
Shimmers in the starlit sky
The stars shine through him
Bright as a child's sparkler.

The ghost, a Mr Seethrough
From somewhere back before
Tiptoes across sea horses
Drifts along the corridor

A bubble in a breath of cold
I've never seen a ghost before.

Mr Seethrough is transparent
Pellucid as a shrimp
Lustrous glass aorta
Opening and closing
Diaphanous Medusa
Umbrella of the deep.

Ghosts I'm told
Take flight
In dawn's half light
As the black bird sings
They spread their wings
And flit like bats
To the attic
But Seethrough dazzles

Even on sunny days
Dancing in the ripples
Of a June heat haze
Glittery ghost.

He waits for the sun to set
Then walks the corridor again
Today he's changed his sex
She wears a dress of silk gossamer
So fine that any bride
Could pull it through a wedding ring
A dragon fly
With ultraviolet wings
Her dress rustling
As she vanishes behind
The diamond window pane
In the mirrors on the wall
She is not seen at all.

Will she be my Mr Seethrough?
Next time she floats this way
One of Della's ladies
Crossing gender in time
With a beard of spun glass
She slips between my fingers
Rippling with laughter.

I thought that ghosts were silent
As glowworm lamps that spark
Opalescent creatures
Of shadow and the dark
Oh how they chatter
Debutantes on crystal stairs
Iridescent matter

Flaring glassy chandeliers
They dance a tinsel quick-step
Pianola phantoms

Swaying seaweed
Sarabands.

As she disappears
I toast my ghost
In acqua vite
Luminous presence
Here and gone.